W9-AYK-993

The College History Series

STONY BROOK
STATE UNIVERSITY
OF NEW YORK

STATE UNIVERSITY OF NEW YORK

announces

the opening of a new college

STATE UNIVERSITY COLLEGE ON LONG ISLAND

at Oyster Bay

in the fall of 1957

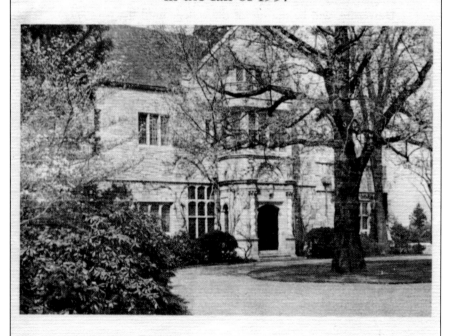

Main entrance to the classroom and administration building.

The State University College on Long Island held its first classes on September 17, 1957, on the grounds of Planting Fields, the majestic 350-acre former estate of benefactor William Robertson Coe. Classes were held in Oyster Bay while a new campus was prepared in the quaint community of Stony Brook, on 480 acres of woodlands donated by philanthropist Ward Melville.

The College History Series

STONY BROOK
STATE UNIVERSITY OF NEW YORK

KRISTEN J. NYITRAY AND ANN M. BECKER

ARCADIA
PUBLISHING

Published by Arcadia Publishing
Charleston, South Carolina

Printed in the United States of America

Library of Congress Catalog Card Number: 2002106595

For all general information contact Arcadia Publishing at:
Telephone 843-853-2070
Fax 843-853-0044
E-mail sales@arcadiapublishing.com
For customer service and orders:
Toll-Free 1-888-313-2665

Visit us on the Internet at www.arcadiapublishing.com

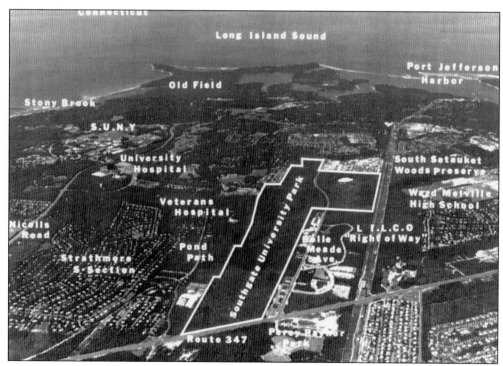

Stony Brook University is nestled on the north shore of Long Island in the historic area known as the Three Villages, located approximately 60 miles east of Manhattan. This aerial photograph of the region, taken in 1990, includes notation of the West and East Campuses, which encompass more than 1,100 acres along Nicolls Road. Stony Brook University has evolved from a modest teacher preparatory college to a world-class research institution with over 90,000 alumni.

CONTENTS

ACKNOWLEDGMENTS

The majority of the photographs in this book were drawn from the University Archives, housed in the Frank Melville Jr. Memorial Library. We would like to thank the following individuals for enhancing this volume with their generous contributions and assistance: Dr. Jorge Benach, assistant professor at Stony Brook University Medical School; Phyllis Bianchet, Stony Brook University, Medical Photography; Josephine Castronuovo, Stony Brook University, Preservation Department; James Cingone, photographer; Ellen Cone-Busch, Planting Fields Foundation; Margaret Conover, Three Village Historical Society; Deborah Dolan; Paul Dudzick, Stony Brook University, Department of Physical Education; Robert A. Emmerich Jr., Stony Brook University, Athletics Media Relations Department; Richard Feinberg, Stony Brook University, Preservation Department; Elizabeth Gasparino, Stony Brook University, C.N. Yang Institute for Theoretical Physics; Helen Harrison, Pollock-Krasner House and Study Center; Maxine Hicks, photographer; Dr. Masayori Inouye, professor and chair, Department of Biochemistry at the Robert Wood Johnson Medical School; Edith Jones, Stony Brook University, Center for Regional Policy Studies; Janice Levy, associate professor and chair, Department of Cinema and Photography, Ithaca College; Lou Manna, Lou Manna Inc.; Karen Martin, Three Village Historical Society; Bill Miller, Stony Brook University, Department of History; Barbara and Jim Mooney, Jim Mooney Photos; Janice Nappe, administrative assistant to Dr. Inouye; Danielle Nevel, Stony Brook University, Communications Department; Jeanne Neville, Stony Brook University, Medical Photography; Robert O'Rourk, photographer; Norm Prusslin, Stony Brook University, *Statesman* and WUSB; Frank Roethal, Stony Brook University, Marine Sciences Research Center; Marylou Stewart, Stony Brook University, Medical Photography; F. Jason Torre, Stony Brook University, Special Collections and University Archives; Dr. C.N. Yang, Stony Brook University, C.N. Yang Institute for Theoretical Physics; Dr. Peter Winkler, Stony Brook University, Department of Music; Kenneth Wishnia; and Joanne Young, Stony Brook University, Educasians.

We wish to extend our gratitude to Stony Brook University President Shirley Strum Kenny and William Simmons, vice president for university advancement and director of the Stony Brook Foundation, for their support of this project.

Ann M. Becker would like to personally thank the people listed above, who assisted in gathering and identifying photographs and verifying facts, for their kind and generous assistance, and her husband, Walter, and children, Katie, Mary Ellen, Alison, and Lyndsay, for their patience, understanding, and support throughout this project.

Kristen J. Nyitray would like to thank all those who assisted with this project for their generous contributions. Special thanks to her entire family for their love and encouragement and to her mother for her guidance and support of this endeavor.

INTRODUCTION

Stony Brook: State University of New York is a photographic representation of the university's evolution from a small teacher preparatory college into a world-renowned research institution. The book provides glimpses of the past beginning in 1957 at the school's first campus, Planting Fields at Oyster Bay, and concludes with the opening of its newest campus, Stony Brook Manhattan, in 2002. For a more comprehensive history of the university, readers may wish to consult *Politics and Public Higher Education: Stony Brook—A Case History*, by Dr. Sidney Gelber.

The Board of Trustees of the State University of New York issued its recommendation for the establishment of a new state-supported and operated college on Long Island on April 15, 1955. After two years of careful deliberations and intensive planning, SUNY announced the opening of the State University College on Long Island. The Board of Regents authorized William Robertson Coe's exquisite 350-acre former arboretum-estate, Planting Fields, as a temporary campus while a new campus was prepared in historic Stony Brook on a 480-acre tract of land donated by philanthropist Ward Melville.

The first day of classes commenced on September 17, 1957. A total of 148 students were enrolled in classes at the tuition-free State University College on Long Island at Oyster Bay. The college's administrators were served with the mandate to "prepare teachers of science and mathematics for secondary schools and community colleges." Course offerings were initially limited to humanities, English (communications), German, social sciences, education, mathematics, and natural science. SUNY expanded the college's scope a year later to include degree programs in the fields of science, mathematics, and engineering.

The preparation of the Stony Brook campus began in 1959, when the State University of New York embarked on a $150 million building program on 480 acres of woodlands in Stony Brook. The construction coincided with issuance of the 1960 Heald Report, a study of New York State's higher education programs commissioned by Gov. Nelson A. Rockefeller. This report recommended that a major new university center be established on Long Island to "stand with the finest in the country." On April 8, 1960, Rockefeller, Ward Melville, and Frank C. Moore, chairman of the SUNY Board of Trustees, turned the first spades of dirt at the formal groundbreaking ceremonies in Stony Brook. The new campus was designated a university center on June 6, 1960, and subsequently renamed the State University of New York, Long Island Center.

Dr. John Francis Lee was appointed as the university's first president on January 1, 1961. His mandate from SUNY was to convert the Long Island Center from a science and engineering college to a full-scale university, complete with liberal arts and sciences programs and a graduate school. Although these edicts were fulfilled, Lee left this post amidst political controversy in November 1961. Thomas H. Hamilton was subsequently appointed as acting administrative head of the university.

The Stony Brook campus opened on Sunday, September 16, 1962, with 780 students enrolled in its programs. The first buildings constructed were the Humanities and Chemistry Buildings and a single, corridor-style dormitory named G Dorm, comprised of two wings connected by a

cafeteria. This building also housed the administrative and faculty offices, the student newspaper, student government offices, and the infirmary. The university continued to embark on a series of expansion projects to meet the needs of its soaring enrollment. By 1964, it offered 232 courses within 14 academic departments in the College of Arts and Sciences and 30 courses under 4 departments in the College of Engineering.

Dr. John S. Toll was inaugurated as the second president of the State University of New York at Stony Brook on April 1, 1965. During his 13-year tenure, the campus experienced unprecedented growth and development. Toll recruited elite researchers and scholars, including Nobel Prize recipient Dr. C.N. Yang, to develop competitive academic departments, with special emphasis on scientific research.

The Muir Report of 1963 recommended to Rockefeller and the SUNY Board of Regents the establishment of a new medical center on Long Island. The complex was to include "schools of medicine, dentistry and other health professions on the State University campus at Stony Brook, Long Island by 1970." The university's administrators began planning for the comprehensive Health Sciences Center on Stony Brook's East Campus. The towers of the Health Sciences Center were completed in three stages between 1976 and 1980 at a cost of approximately $300 million. Today, the complex is comprised of the Schools of Dental Medicine, Health Technology and Management, Medicine, Nursing, Social Welfare, and the Long Island State Veterans Home.

John H. Marburger III was appointed as the third president of SUNY Stony Brook in 1980. During his presidency the 540-bed University Hospital opened, the Fine Arts Center was renamed Staller Center for the Arts in honor of benefactor Max Staller, and the Stony Brook Foundation acquired the Pollock-Krasner House, the former home and studio of artists Jackson Pollock and Lee Krasner. Stony Brook's reputation as a center of scientific excellence continued to expand as it embarked on a joint venture with Brookhaven National Laboratory, Cold Spring Harbor Laboratory, and North Shore Hospital to create the Long Island Research Institute in 1992.

A new era in Stony Brook's history began on September 1, 1994, when Dr. Shirley Strum Kenny assumed the presidency of the university. Under Kenny's leadership the university has continued to thrive. A 1997 national study ranked Stony Brook one of the top three public universities in the nation in the combined research areas of science, social science, and arts and humanities. University Hospital was named one of the top 15 teaching hospitals in 1998 in a study that examined 3,575 hospitals nationwide. Stony Brook obtained 12th ranking among all colleges and universities in the United States in royalties generated from inventions licensed to industry ($12 million), accounting for 98 percent of all SUNY-system licensing revenue.

The campus has also transformed physically as Kenny's vision of a "heart of the campus" has come to fruition. Stony Brook's six-acre central mall has been completely redesigned and now features fountains, lush gardens, and a "brook." The university is currently in the midst of several expansion projects including the completion of a 7,500-seat sports stadium. Charles B. Wang of Computer Associates presented $25 million to the university in 1996 for the construction of an Asian American Studies Center. The university's newest facility, Stony Brook Manhattan, opened in January 2002.

Stony Brook University has evolved from a teacher's preparatory college into a world-class research institution. The combined efforts of its dedicated students, faculty, and staff have led to the fulfillment of the university's original mandate to "stand with the finest in the nation."

One

THE "NATION'S MOST BEAUTIFUL CAMPUS"

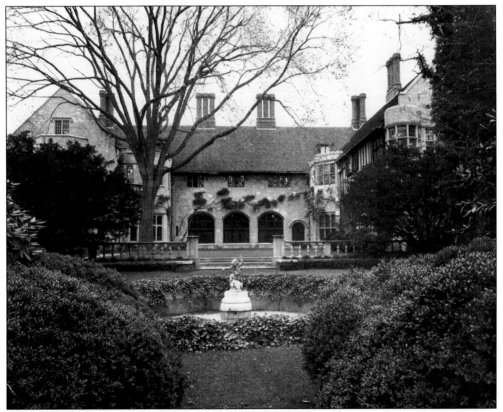

The State University of New York announced the opening of the State University College on Long Island at Oyster Bay in 1957. William Robertson Coe's exquisite arboretum-estate, Planting Fields, was authorized as a temporary campus while SUNY's newest campus was under construction in the charming village of Stony Brook, on a 480-acre tract of land donated by philanthropist Ward Melville. The magnificence of Stony Brook University's first campus inspired one newspaper to name it the "Nation's Most Beautiful College Campus."

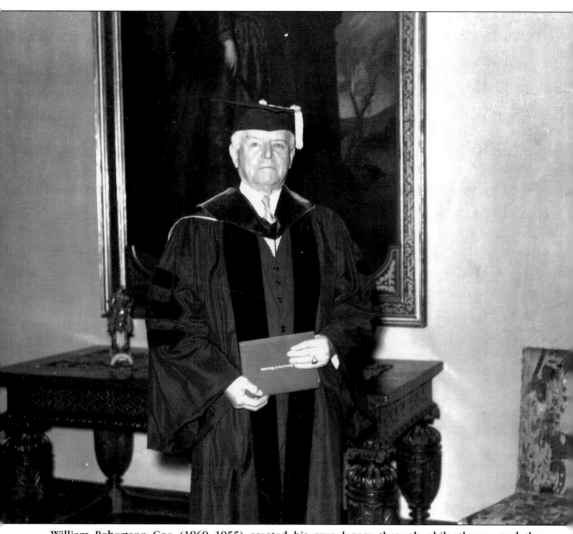

William Robertson Coe (1869–1955) created his own legacy through philanthropy, and the State University of New York is one of many institutions of higher learning to benefit from his generosity. Born in England and raised in Philadelphia, Coe rose from humble beginnings as an employee at Johnson and Higgins, a marine insurance brokerage and adjustment firm, to become its president and chairman by the age of 40. His philanthropic gestures include the donation of his vast collection of American West manuscripts, diaries, and memorabilia, valued at over $3 million, to Yale University in 1948. Through funding from his Coe Foundation, 40 colleges and universities instituted American studies programs and three endowed professorships were established at the University of Wyoming, Stanford University, and Yale University. In 1949, he bequeathed his impressive estate, Planting Fields, to the state of New York for use by its university system. Coe is pictured at Planting Fields in 1952, after receiving an honorary degree from the University of Wyoming. (Courtesy of the Planting Fields Foundation Archive.)

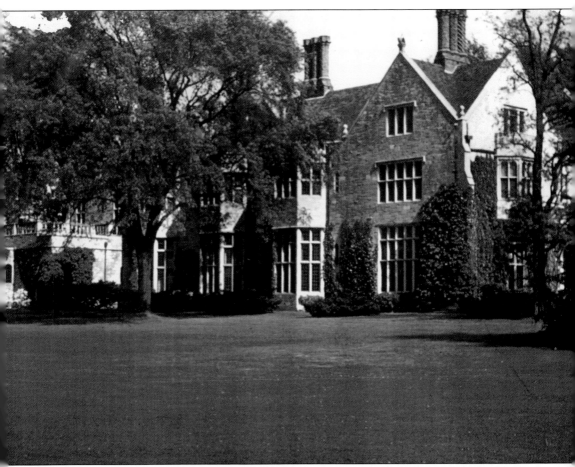

The Matinecock people of Long Island were the first to cultivate the soil and harvest crops on land they called Plantings Fields. By the mid-17th century, Dutch settlers began to inhabit Oyster Bay, sustaining themselves by farming and fishing. Industrialization and transportation improvements in the late 19th century transformed the community, as grand Gold Coast mansions replaced open fields along the north shore of Long Island. William Robertson Coe purchased the 353-acre Planting Fields estate at a cost of $625,000 from Helen Byrne in 1913. After the original mansion was destroyed by a fire, Coe and his wife, Mai Rogers Coe, commissioned A. Stewart Walker and Leon Gillette to design an English Tudor Revival mansion. Inspired by the grand manor homes of England, the mansion's façade features Indiana limestone with half-timbering accents. The 65-room home accommodated a family of 6 and 30 servants. Each family member's bedroom included a fireplace and an adjoining bathroom, complete with gold fixtures and butler buttons. The construction of the home was completed in 1921 at a cost of $1 million. (Courtesy of the Planting Fields Foundation Archive.)

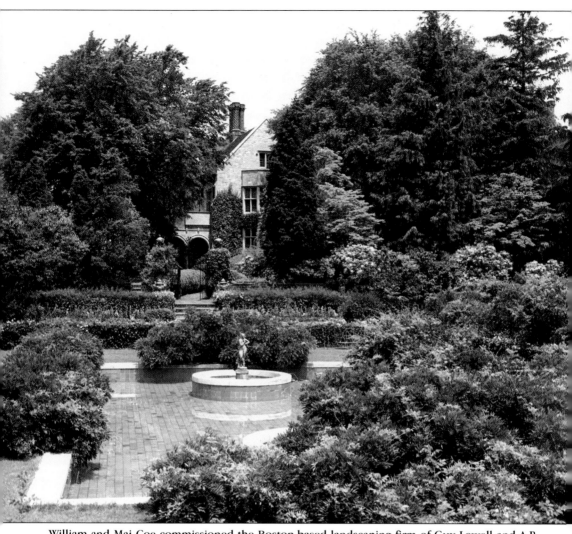

William and Mai Coe commissioned the Boston-based landscaping firm of Guy Lowell and A.R. Sargent to refine the grounds at Planting Fields. Lowell and Sargent designed the estate's elegant Italian Blue Pool Garden and supervised the transport of Mai Coe's two beloved purple beech trees from Massachusetts to Planting Fields via Long Island Sound. The Olmstead Brothers of Massachusetts were retained from 1918 t o 1944 to expand upon Lowell and Sargent's landscape enhancements. Under the direction of James Frederick Dawson, the grounds were transformed to resemble the English countryside. The arboretum includes a rich assortment of trees and shrubbery, including rhododendrons, imported Japanese cherry and crabapple trees, dogwoods, azaleas, and oaks. The total cost for creating this horticultural wonderland amounted to nearly $1.3 million. The Planting Fields Foundation, in cooperation with the New York State Office of Parks, Recreation, and Historic Preservation, has assumed the responsibility of preserving, restoring, maintaining, and interpreting Coe Hall at Planting Fields Arboretum State Historic Park since 1978.

Leonard K. Olson was named dean of the State University College on Long Island on February 14, 1957. His administrative duties included managing the Oyster Bay campus and overseeing the planning of the Stony Brook campus. Olson traveled throughout the United States recruiting top faculty, for he intended "this college to set a high standard of academic excellence." The 14 professors he appointed had formerly held positions at Oxford, Columbia, Yale, and the University of Chicago.

W. Allen Austill, a former colleague of Leonard Olson at the University of Chicago, was appointed as dean of students in May 1957. Austill, a strong advocate for students' rights, was a beloved figure at the Oyster Bay campus. The Class of 1961 dedicated the first edition of *Specula,* the school's yearbook, to Austill, stating that "He has listened to our problems, guided our decisions, shouldered our burdens, and furthered our objectives . . . he has been our opponent, our protector, our champion, our friend."

The transformation of Coe Hall from a grand family compound to a college campus required months of careful planning and preparation. Initially, the estate was not equipped with a heating element or telephones. Electricians worked at a feverish pace to wire the building and install fire alarms. The students attending classes in the estate nicknamed the construction workers "C.B.'s," or "Coe Builders."

The mansion's six bedrooms, complete with fireplaces and hand-painted decorative murals by American society painter Robert Chandler, were converted into classrooms. Bathrooms and dressing rooms were modified to provide faculty with offices and laboratories. The servant's quarters were transformed into the men's dormitories, which could accommodate 24 residents.

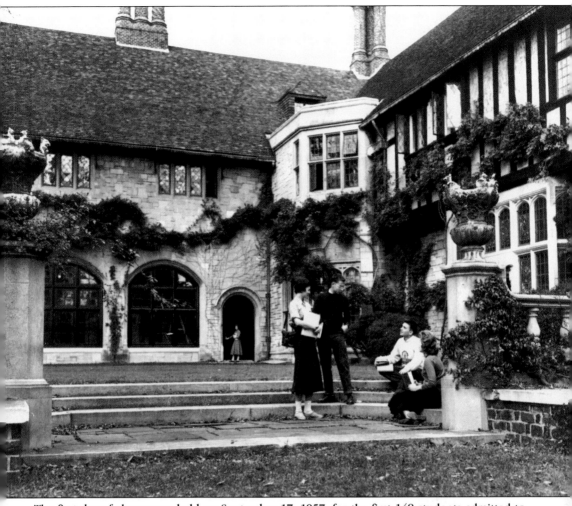

The first day of classes was held on September 17, 1957, for the first 148 students admitted to the tuition-free State University College on Long Island. After attending a welcoming address by Dean Leonard K. Olson, students were taken on a 15-minute tour of the Coe Estate and grounds. After several years of intensive planning by the State University of New York, the college had become a reality.

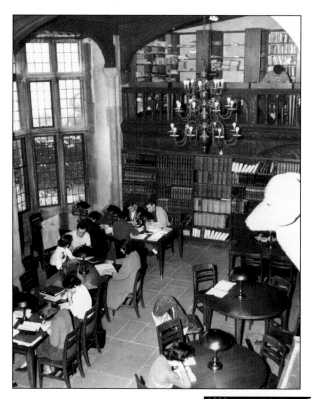

The main floor of Coe Hall consisted of a dining hall, a cafeteria, an all-purpose room, the Coffee Shop, a lounge, a library, and the Great Hall. Massive portraits, rich tapestries, and moose and elk heads adorned the first-floor walls. In the library, leather-bound volumes filled the bookcases, and newly electrified desk lamps and chandeliers provided ample lighting.

An Elizabethan-inspired, carved granite staircase led to the six second-floor classrooms, furnished with seminar tables to accommodate classes in the humanities, English (communications), German, social sciences, education, mathematics, and natural science. The third floor was reserved for faculty offices and a student-faculty lounge. The elevated, second-floor hallway featured exposed ceiling beams, hand-carved railings, and stained glass panels.

16

The State University College on Long Island held its students to a high academic standard. According to its admissions bulletin, the college only accepted students who were "of serious intellectual purpose" and had "demonstrated academic competence and personal merit." The college emphasized the importance of acquiring basic competencies before subject specialization. The students pictured here are studying in the library.

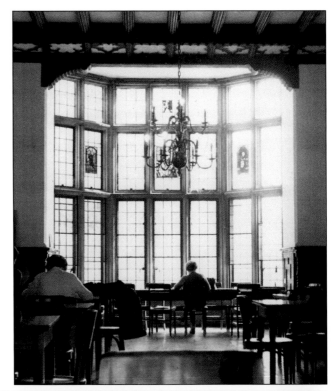

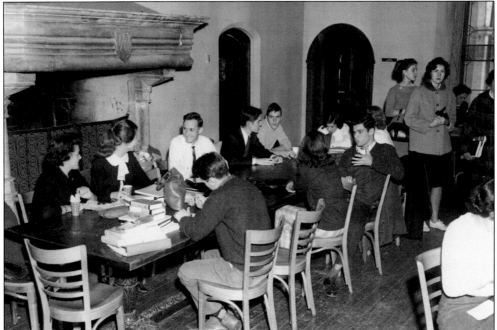

The college did not initially assemble sports teams or organize extracurricular activities. Consequently, the Coe Hall Coffee Shop became the center of the social activity. The attractiveness and acoustics of this space made it a favorite gathering spot for students and faculty to discuss class assignments and upcoming campus events.

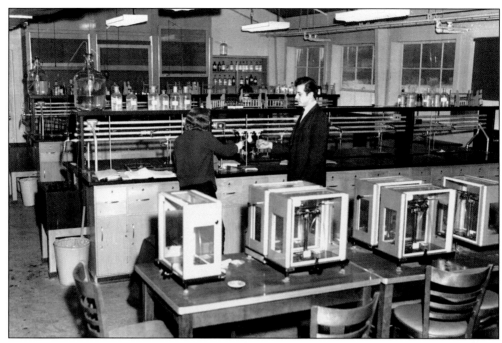

The State University of New York extended the college's mandate to include degree programs in the fields of science, mathematics, and engineering. While tuition remained free for students preparing for careers as teachers, the enrollment fee for programs in mathematics, science, and engineering was $375 per year for New York residents and $455 for out-of-state students. Prefabricated buildings were installed in close proximity to Coe Hall to provide additional space for classrooms, laboratories, and faculty offices.

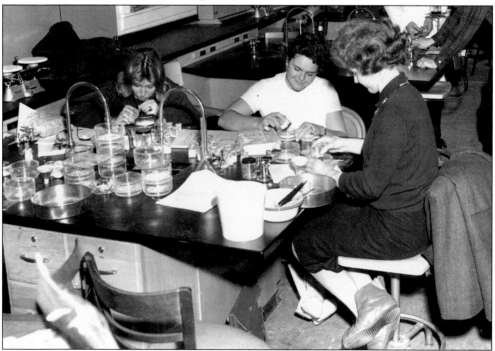

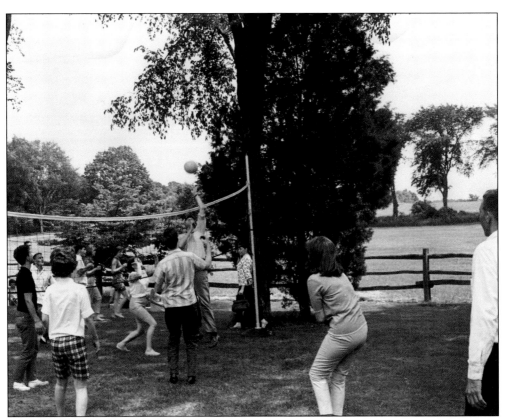

In an effort to encourage school spirit, classes were canceled on October 30 for the college's first attempt to establish a tradition, referred to as Nameless Day. Students challenged the faculty to softball and volleyball games, tug-of-war competitions, and egg-tossing contests. The day commenced with a picnic on the grounds of Coe Hall and dancing in the cafeteria.

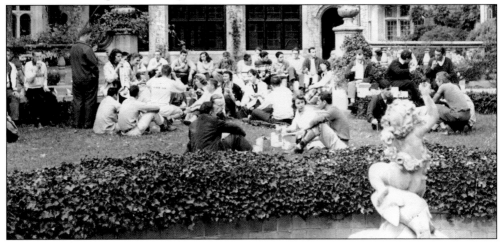

Sucolian

Vol. II No. 1　　　　Official Student Newspaper Of State University College On Long Island　　　Oyster Bay　　　November 5, 195

New Year.. New Students Same Old Grind

Now that the school year is once again in full swing and everyone walks around campus with that familiar "Do you know what he's talking about?" expression, aside from becoming acquainted with new work, everyone is making new friends. There are plenty of new people to meet. The freshman class numbers 168, more than twice the number of upperclassmen.

This year's frosh come to us from many different schools all over the state and a few even from other states. Though they have greatly diversified backgrounds, their goals are similar; a future in math science or engineering.

T o make these entering Freshmen feel at home and to help them to know the school, the Faculty and the other students, an orientation program was initiated. For this purpose an orientation committee was set up composed of six Faculty members and eight upperclassmen. Head of the Faculty division was Mr. Levin. The Sophomores, Elizabeth Joyce, Michael Coglianese. MarvLouLionells, Rosemarie Capone, Ronald Warmbier, Eugene Dailey, George Many and chairman Arthur Whelan would help theFreshmen acquaint themselves with the College community in the brief space of one week. A schedule of events was drawn up which served to keep the students interested and busy.

After the residents moved in on Sunday, September 14, there was a buffet supper served on the patio. This was followed by a general meeting of the resident students. That night the first of a series of

record hops was held. These informal mixers followed the planned activities of each day.

Monday marked the arrival of the commuting students. The class as a whole was greeted by address- es by Dean Olsen and Dean Austill. Afterwards tours of the campus were conducted by Orientation Board members. The activities of Monday afternoon an Tuesday morning were not as pleasant as the preseding ones because at these times placement exams were give, but the function of the orientation program was to give the students a taste of college life and work is definitely an integral part. Tuesday afternoon was an orientation seminar and a meeting of the freshmen class followed by a picnic supper and a movie in the Great Hall. Wednesday greeted the new class with more placement tests and another seminar.

Thursday the only freshman activities were appointments at the Health Office and getting their first glimpse of the sophomore class as the upperclassmen arrived en masse for registration. Friday morning was frosh registration at last and each new student became a part of the college community. That afternoon the first meeting of the entire student body was held. This was followed by a picnic supper and a square dance which was a definite social success.

Finally, the tea on Sunday held by the faculty wives, wound up a very pleasant and memorable start of each freshman's college career.

Frosh Hold Elections

The electing of freshman class officers took place on Monday, October 26. The ballots were counted in the Great Hall on the following Thursday in the presence of the candidates or their representatives and members of the student body. Thomas Bergin, a graduate of St. Dominick's High School in Oyster Bay was elected president. Ellen Joyce, the third member of that family to matriculate at SUCOLI, was elected Vice-President. Alice Lieberman won, by an wide margin, the secretarial post of the freshman class. Hank Liers was awarded the office of treasurer. Both the

secretary and treasurer are graduates of Mepham High School in Bellmore.

The counting of the ballots ended an eventful two week period which began with the announcement of the candidates. The appearance of campaign posters, buttons and personal electioneering marked this period.

The rules governing the elections were drawn up by a committee consisting of Elizabeth Joyce, George May and J, Rodger Morphett. This committee, headed by Miss Joyce was appointed by Dean Austill. In the main, the candidates abided by the regulations set forth. However, due to a misunderstanding of the regulations, infractions were perpetrated by some candidates necessitating action by the board.

Interestingly, the one campaign procedure that seemed the most

unimportant to the candidates, turned out to have quite important results. Many of the candidates seemed to underestimate the value of the assembly at which they gave their prepared speeches. Not having any platform, they believed that there was really nothing to say. The campaign assembly was for many the first opportunity to view the candidates. Needless to say the results of these speeches were quite illuminating. The impressions made on the students at this meeting probably determined their vote.

The SUCOLIAN congratulates the winners and gives its sincere hope that they may carry out the business of the freshman class in the best custom of the College; to this end the staff volunteers themselves to assist them in any way possible.

Soph Officers

The Sophomore class has once again set a precedent by electing the first class officers in the one year history of the College. Elections were held at the first class meeting, September 18. Al Ratto was awarded the office of President; Rose Capone, Vice-president; Marylou Lionells, Secretary; and Elizabeth Joyce, Treasurer.

Due to the resignation of Mr. Ratto new elections were held on October 21. Miss Capone was chosen as the new President and Ed Farnworth is the new Veep. The other officers retained their titles.

These officers shall serve throughout the academic year 1958- 59. Their work thus far has been confined to drawing up the rules governing Freshman elections and working with the Frosh officers to make up a draft of a Constitution for Student government.

The views and outlook of the Sophomore officers summed up by Miss Capone in these words; "I feel our outlook is a very optimistic one. We hope that all will help to realize it. Many seem to mumble the words 'lack of class organization' in one form or other but we should all realize that we are united if only in the fact that it is the duty of each and every one of us to take a good hold of our responsibilities towards ourselves. We must put every effort into making this school year, and the next two years, as successful as possible.

I don't mean to imply that we should be like the child having no sense of judgement, who, when offered a piece of candy, will take a bite which is much too big to chew and will proceed only to regurgitate. We should, not like the child, but as mature individuals and as a unified Sophomore class, work together toward future maturation and development, both as individuals and as an integral part of the whole which constitutes this institution. We should all take a small bite of the projects and problems which will confront us and proceed to chew, swallow and digest this little bit as well as we can. We may not feel that we have accomplished much but I'm sure that an accumulation of little bites, well digested, will add up to a successful college career for us all.

We need some starting point and that point is directly ahead of us -- the establishment of an organized student government. From this point let us proceed."

Masque Ball

The second Annual Fall Dance was sponsored by the women of Beta Phi and held Saturday Nov. 1 in the Great Hall.

The theme was Halloween, with multitudes of pumpkins, gourds, squash and cornstalks cleverly arranged around the room. One would hardly have recognized the familiar lecture hall.

The dance was a masquerade with costumes being optional. Approximately one third of the fifty eight couples in attendance wore costumes. The varying attire ran from vampires to clowns with Maverick's and flappers in between.

(Continued on page three)

DEAN MEETS UPPER CLASS
RESTATES SCHOOL'S AIM

Yesterday afternoon Dean Olsen called the Sophomores together for a meeting in the Great Hall. The purpose of the meeting, explained Dean Olsen, was to illuminate the College's position with respect to the recent misapprehensions of the Sophomore Class. It was brought to his attention that many Sophomores regarded the curriculum as existing expressly for the purpose of reducing their class to a minimum.

Soph Impressions

Early each morning, driving along 25 A on the way to school, I wave smartly at SUCOLI's alumni turning smartly into the Post campus. I drive on towards the college, joining obediently at each State University College on Long Island direction sign. Entering the parking lot, I squeeze my B parking sticker bearing Jaguar between two generous C stickers, sardine style.

I smile happily at some of my classmates and stalk up the path to Coe Hall. In the cafeteria I join that self-conscious island of Sophomores within the sea of eager Freshmen. We sit and count noses..... 1, 2, 3,72, 73. All here! We look at each other bravely and make silent resolutions.

On the way to my first class I peek into a Nat. Sci. I laboratory. Athletic Freshmen, and Sophomores, are scrambling on top of the workbenches and swinging energetically at each other with lead bobs. Fortunately, these bobs are attached to the benches with thin, but strong twine, and the lead bobs do not quite connect with the intended targets. The lab instructor looks up at me. I ask: "Are we going to do this too in the Physics 20 lab?"

"This is too advanced for you people." is the reply. Oh, well. I walk into a classroom. Twenty indignant Freshman faces stare at me. Wrong room! I enter the Sophomore bastion...Humanities II. After an enlightening lecture and discussion, I return to the cafeteria for the mid-day meal. A threatening group of Freshmen advance on me. "You will vote for me in the elections?" I explain that Sophomores cannot vote for Freshman class

(Continued on page four)

The aim of the College, explained Mr. Olsen, is to prepare qualified students to become educated, competent and able in their fields of endeavor. In addition, the College has the obligation to the citizens of the State of New York to provide teachers of Science and Mathematics who will be leaders in their fields. It is the responsibility of the students to understand and fully fill their part in achieving these ends. The College provides a Faculty which exemplifies these qualities and a program or curriculum which is designed to guide the students towards the attainment of these chosen ends. This Faculty this program and the students are intimately involved in the success of this institution. The link between the College, the Faculty, and the students is the program designed by the Faculty. In order to improve the effectiveness of the program it must necessarily be adaptable and changeable.

To this end, it is the duty of the Sophomore Class to communicate with the Faculty and Administration, either through class discussion or through its officers its problems, criticisms and suggestions pertaining to the curriculum.

It is unfortunate that because of the hasty and unheralded opening of this College, some unqualified students were admitted. The College felt that it is often very difficult to tell from past performance whether a student will be able to apply himself successfully to the rigors of college studies. The State University's motto; "Let Each Become All He Is Capable Of Being" governed the College's decision to accept a number of students who had not completed all the academic requirements. It is for this reason that

(Continued on page four)

Under the direction of editor Henri Smit, the first student publication, the *Sucolian* (derived from the State University College on Long Island), was published in February 1958. In its premier issue, the newspaper featured an interview with Dean Leonard K. Olson, faculty biographies, a sports report, and a gossip column. A year later the newspaper was renamed the *Statesman*.

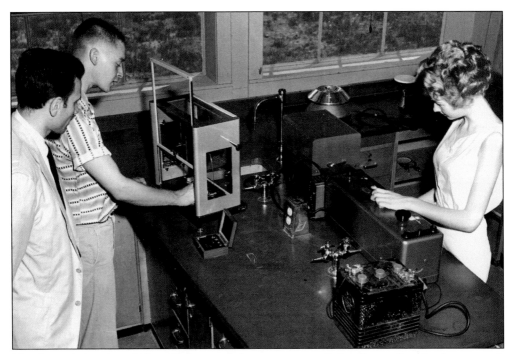

The State University of New York awarded one quarter of the Oyster Bay faculty research grants in 1958. Dean Leonard K. Olson's aggressive recruitment efforts continued, as he doubled the faculty size to include 28 members by the fall 1958 semester. Newly hired professor Dr. Joseph Silverman (left) of the Chemistry Department is pictured in a laboratory with two Natural Science I students.

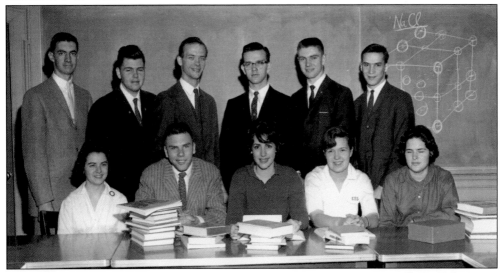

The college required students to complete 128 credit hours in order to obtain bachelor of science degrees in chemistry, physics, biology, and chemistry. The Chemical Society, one of the first student organizations assembled on campus, often held study sessions in Coe Hall. Pictured, from left to right, are the following: (front row) Caroline Mayo, John Krawczyk, Jane Gilbert, Lynne Geed, and Shelley Silverman; (back row) Joe Hovanec, Tom Jones, Dick Blumhagen, Fred Fritz, Roger Renke, and Steve Heller.

Female students were now residing on campus in the Coe Estate, under the watchful eye of Margaret Grace. The dormitory's housemother implemented strict curfews and rules, including the diligent use of a sign-in book. The school's male residents were transferred to the Haybarn, the renovated stables that had formerly served the Coe family.

The sorority Beta Phi was comprised of 12 women, who promoted "school spirit and student activity, while trying to improve social life on campus." Members of this group organized formal dances, sponsored a girls' softball team, and lead toy drives. Beta Phi and the male dormitory residents provided tours to more than 500 visitors during the State University of New York's Open House Week. New York Gov. W. Averell Harriman intended these tours to bring attention to the public university system.

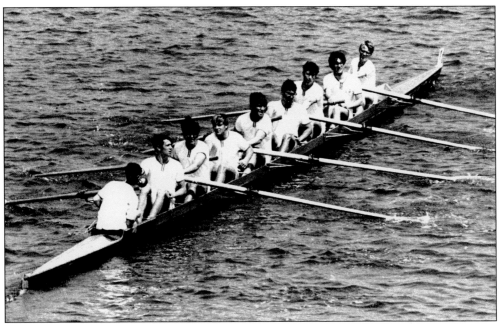

The crew team, coached by Al Borghard, competed in the college's first intercollegiate meet and won the college's first athletic trophy against Clark University. Sophomore John Roberts suggested the team's name, the Soundsmen, in a campus naming contest. SUNY changed the team colors of the school from blue and gold to red and gray a few months later.

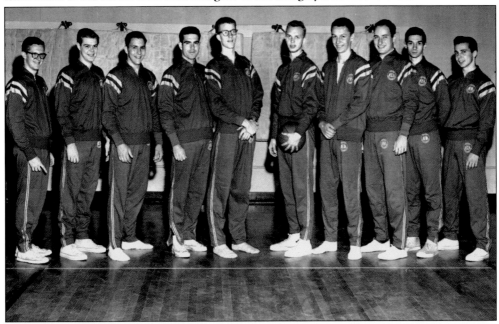

The men's basketball team, headed by coach Bill Riethle, was assembled in the spring. Despite a losing record, an optimistic attitude prevailed, as team members stated in the *Sucolian* that they "would like to win, but they would rather play and lose than not play at all." Pictured, from left to right, are Marv Rosenberg, Jack Mattice, Tom Boyuka, Frank Carr, Charlie Tebbe, Hank Liers, Doug Milne, Ed Beuel, Joe O'Carroll, and Bill Eiffler.

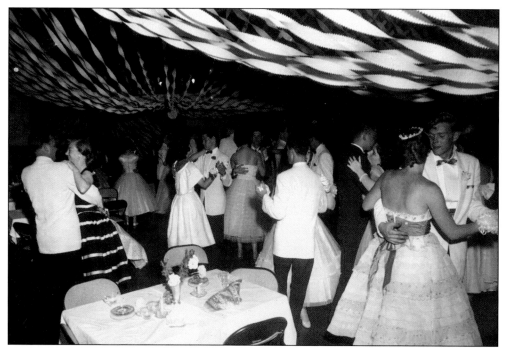

Students and faculty danced to the music of two bands at the Spring Formal hosted by the freshman class. The cost of admission to the June 4 event was $1 per couple. Coe Hall was transformed for the evening, with hundreds of streamers that formed striking canopies, and multicolored lights that illuminated the estate's formal gardens and fountains.

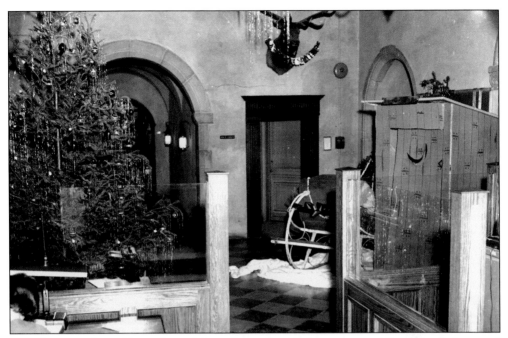

Later that year, class officers planned the college's first Christmas party while students decorated Coe Hall for the holiday season. The first floor featured a large Christmas tree, tinsel roping around the moose heads, and an elaborate sleigh. As a joke, students gift-wrapped the car of Prof. Merrill Rodin, a Triumph, and placed it in the main foyer.

University administrators canceled classes on eight occasions when severe snowstorms hit Long Island. This commuter student may have been one of the many people marooned on campus during one particularly heavy snowfall. Students welcomed these unexpected breaks, using cafeteria trays as toboggans to race down Planting Fields's sloping landscape.

25

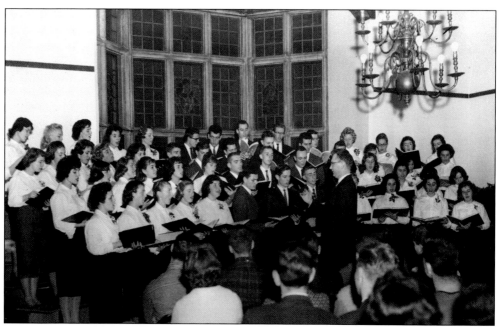

The annual Christmas party, organized by the college's class officers, was held in the Great Hall. Students and faculty gathered for an evening filled with holiday music and entertainment. The event featured the 40-member chorus, directed by Dr. Frank C. Erk, professor of science and mathematics.

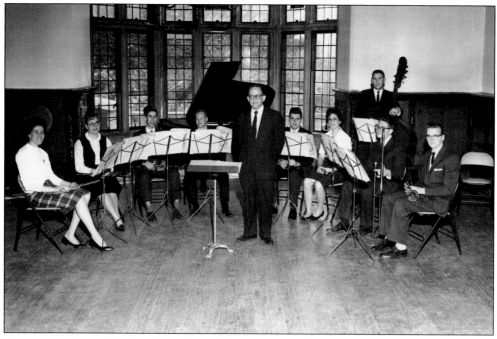

Composer and musician Dr. Isaac Nemiroff (center) was a founding member of the university's music department. Under the direction of Nemiroff, the instrumental group held its first concert in 1960. Pictured with Nemiroff are, from left to right, Lois Ginsberg, Judy Intrator, Carl Baron, Burt Marks, Tom Jones, Ruthann Brody, Steve Auerbach, Richard Fowber, and Bob Hill.

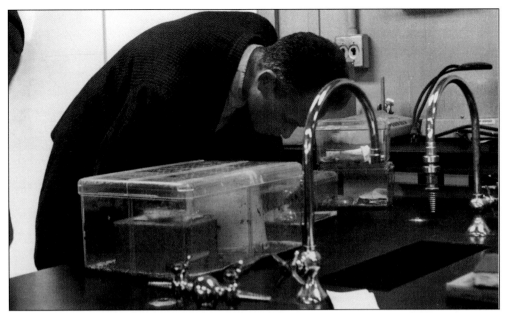

According to the *Sucolian*, biologist Dr. Sol Kramer joined the faculty in 1959 because he was attracted to the natural beauty of the campus and its unlimited opportunity. Kramer stated that "Faculty and students are setting their own standards and are not bound by rigid and ancient traditions." He was the recipient of the first sponsored project award offered by the National Science Foundation. This $13,000 grant supported his research on the parental behaviors of pigeons.

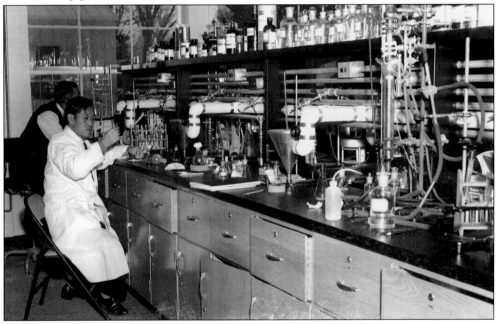

Dr. Fausto Ramirez, professor of organic chemistry, was the recipient of one of the university's largest research grants. The National Cancer Institute awarded Ramirez $100,000 to research and determine whether organic compounds in phosphorus contained anticancer properties. Pictured is Ramirez's laboratory and members of his international research team.

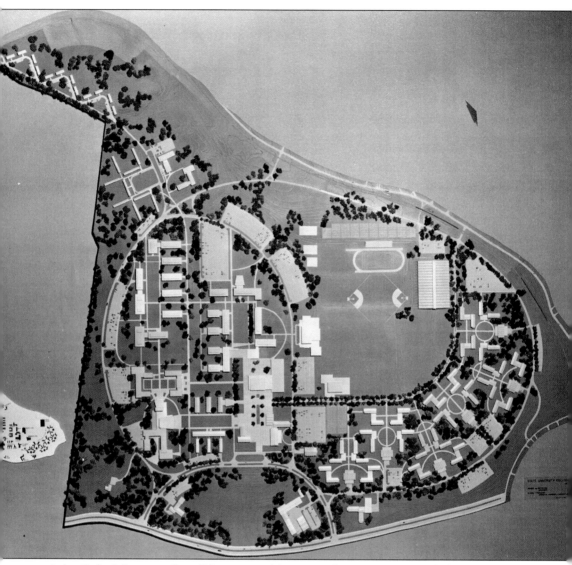

A detailed miniature replica of the proposed Stony Brook campus was unveiled in the main foyer of Coe Hall on January 7, 1960. According to the campus newspaper, the *Sucolian,* students were fascinated by "the proximate plans for the vast future campus." Before its exhibit at Oyster Bay, the scale model, originally constructed in 1958, was on display in the capitol building in Albany.

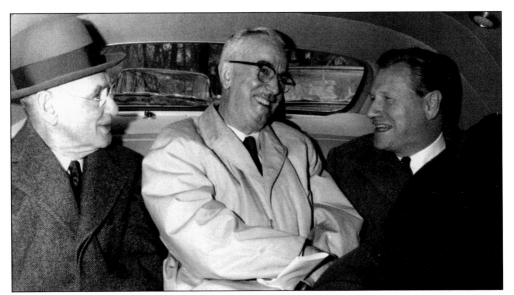

The 1960 Heald Report, a study of New York State's higher education programs commissioned by Gov. Nelson Rockefeller, recommended that a major new university center be established on Long Island to "stand with the finest in the country." Pictured arriving at the university's future site in Stony Brook for groundbreaking festivities are, from left to right, philanthropist Ward Melville, SUNY Board of Trustees chairman Frank C. Moore, and Gov. Nelson Rockefeller.

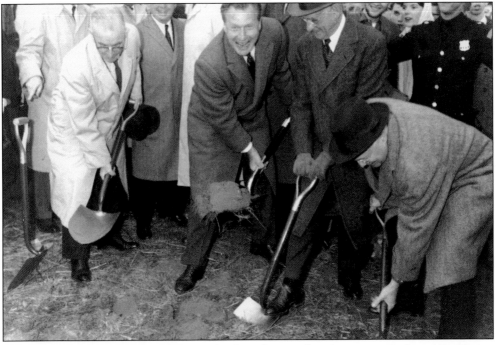

Turning over the first spades of dirt at the formal groundbreaking event in Stony Brook are, from left to right, Frank C. Moore, Gov. Nelson Rockefeller, and Ward Melville. The festivities were held just south of Stony Brook's Long Island Rail Road station on April 8, 1960. Between 1956 and 1968, Ward Melville and his wife, Dorothy Melville, donated more than 600 acres in Stony Brook to the state of New York.

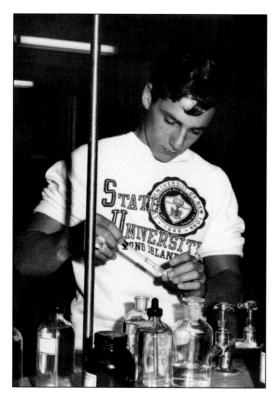

SUNY Trustees designated the Stony Brook campus as a university center and officially changed its name from the State University College on Long Island to the State University of New York, Long Island Center, on June 9, 1960. The university was authorized to award the following degrees: bachelor of arts in the humanities and social sciences; bachelor of engineering science; bachelor of science in the biological sciences, physical sciences, and mathematics; master of arts; master of sciences; and doctor of philosophy.

Dr. John Francis Lee, the former chairman of the Mechanical Engineering Department at North Carolina State, was appointed as the first president of the State University of New York, Long Island Center, on January 1, 1961. His mandate from SUNY was to convert the Long Island Center from a science and engineering college to a full-scale university, complete with liberal arts and sciences programs and a graduate school. Lee served as the university's president through November 9, 1961.

The first student government organization, Polity, was established in 1959, after 165 students ratified an amended form of the Polity Constitution. In its first year, the organization received allocations from SUNY that amounted to about $12,500. Pictured, from left to right, are Polity Executive Committee members Rosemarie Capone (moderator), Mel Reich (treasurer), Cornelia McCormack (corresponding secretary), and Ann Meilinger (recording secretary).

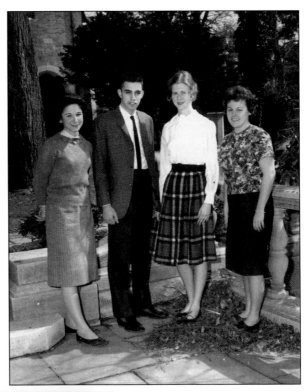

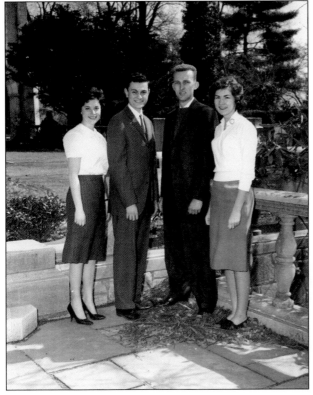

Each class elected a fellow student to serve as its advocate at campus decision-making meetings. Class representatives were members of the executive committee of the student government organization, Polity. Pictured, from left to right, are the first class officers, Amy Aronson (1963), Mike Nofi (1964), Ed Farnworth (1961), and Carol Williamson (1962).

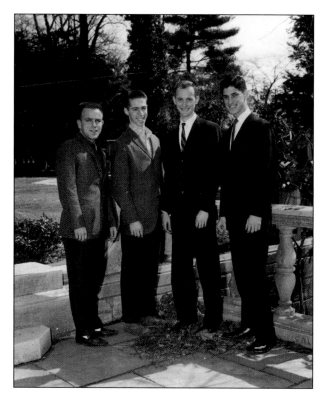

The university's first class president, George May (Class of 1961), held positions in 14 campus clubs and organizations, including the Orientation Board, *Specula,* and the *Statesman.* Pictured, from left to right, are the first four class presidents of the State University of New York, Long Island Center, Fred Schubert (1962), Phil Mighdoll (1963), George May (1961), and Ted Hajjar (1964).

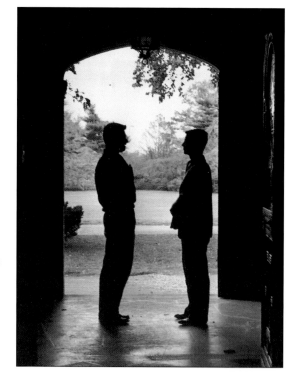

The campus newspaper, the *Statesman,* sponsored a Name the Yearbook contest in 1961. Alice Lieberman was awarded a $10 cash prize for submitting the title the *Spectrum.* The yearbook was later renamed *Specula* since the science department had already used the *Spectrum* for its own publication. This photograph of two students in silhouette is featured on the first page of the 1957–1961 edition of *Specula*.

The Class of 1961, the first class to graduate from the State University of New York, Long Island, poses in the west portico of Coe Hall for a yearbook photograph. Pictured, from left to right, are the following: (front row) June Dawson, Hildegarde Kurnol, Nancy Nevole, Delores Baker, Marie Collins, Gail Bolz, Patricia Cullen, Irene Hanley, Marie Hoff, Marylou Lionells, Cecelia Maiwald, Charlotte Wright, Carol Berggren, and Kathy Barrett; (middle row) Al Ratto, Carl Schulz, Shelly Weinberg, John Nagle, Gordon Little, Eric Knufke, Pete Vallely, John Roberts, Paul Rizzo, Ronny Warmbier, and Frank Carr; (back row) Alban Gass, Bill Snyder, Bob Victor, Jesse Nicholson, George May, Bill Hahl, Ed Farnworth, Mel Morris, Doug Hinka, Bob Walker, and Paul Beck.

The lush landscape of Planting Fields served as an idyllic setting for the university's first commencement exercises, held on June 4, 1961. Prof. Edward Fiess served as marshal, and Prof. Frank Erk performed "Pomp and Circumstance, No. 1" on the organ. The chorus, wearing red robes borrowed from Adelphi University, led the procession. After an address by Pres. John F. Lee, Dean Leonard K. Olson awarded 25 students bachelor of science degrees.

State University of New York
Long Island Center

on the recommendation of the faculty
and by virtue of the authority vested in them
the trustees of the University have conferred on

the degree of
Bachelor of Science

Given this................day of June one thousand nine hundred and sixty-one.

CHAIRMAN OF THE BOARD OF TRUSTEES

PRESIDENT OF THE UNIVERSITY

CHAIRMAN OF THE COUNCIL

PRESIDENT

Two

A VISIONARY'S GIFT

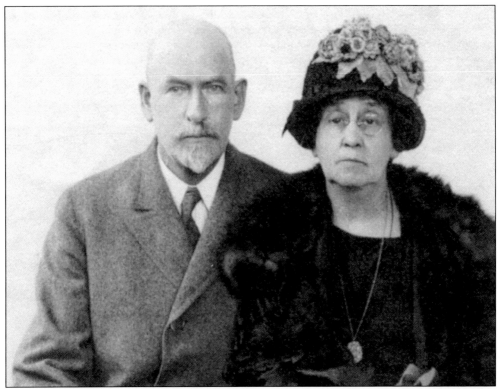

Frank Melville. Jr. and his wife, Jennie Melville, rose from humble beginnings and founded the Melville Shoe Company in 1892. Their small business thrived and evolved into the Melville Corporation, with holdings that included the 5,000-store shoe chain Thom McAn, named by their son, John Ward Melville. The Melvilles vacationed each summer in Stony Brook and, in 1919, they commissioned a home to be built in the Three Village area. (Courtesy of the Three Village Historical Society.)

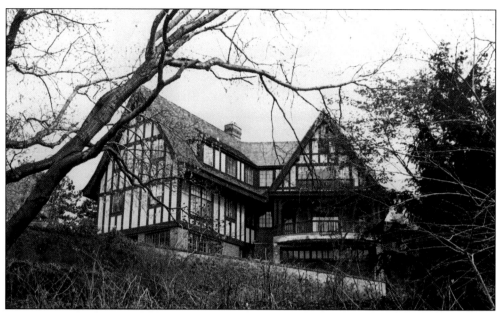

Jennie Melville selected architect Katherine Budd to design a Neo-Tudor-style mansion on 29 waterfront acres in the neighboring village of Old Field. The 40-room home, named Sunwood, was set high on a high bluff overlooking Long Island Sound and Smithtown Bay. The mansion featured a stone tower, decorative iron gates, and extensive gardens. Although the family's primary residence was located on 5th Avenue in New York City, they summered and spent each Christmas at their Long Island estate.

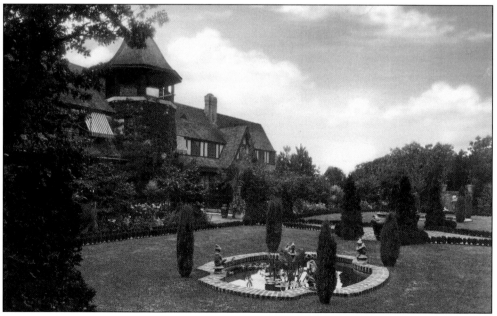

Designed by Jennie Melville, the gardens at Sunwood showcased specimen plants and trees, complemented by bricked paths and miniature fishponds. Decorative wrought-iron gates led to beautiful reflecting pools and tiered lawns, which provided unobstructed views of Long Island Sound.

The vision of Ward Melville (1887–1977) shaped the character and landscape of the Three Village's communities of Stony Brook, Setauket, and Old Field. Under his leadership, the area was transformed from a simple seaside village to a nationally recognized model for Colonial restoration. Melville made the first of many gifts to the State University of New York in 1956, when he donated more than 400 acres of land in Stony Brook and his parent's Sunwood estate for use as a college campus. (Courtesy of the Three Village Historical Society.)

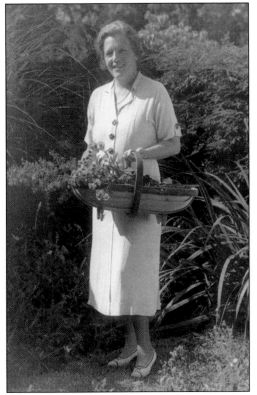

Dorothy Bigelow Melville (1894–1989) shared her husband Ward Melville's passion for volunteerism, philanthropy, and historic preservation. In additional to her local charity work, she served as a nurse's assistant in World War I and aided the Red Cross in World War II. She was also a staunch supporter of preservation initiatives, serving as chair of the Suffolk Museum, president of the Frank Melville Jr. Memorial Foundation and the Three Village Garden Club, and board member of the Stony Brook Construction Fund. (Courtesy of the Three Village Historical Society.)

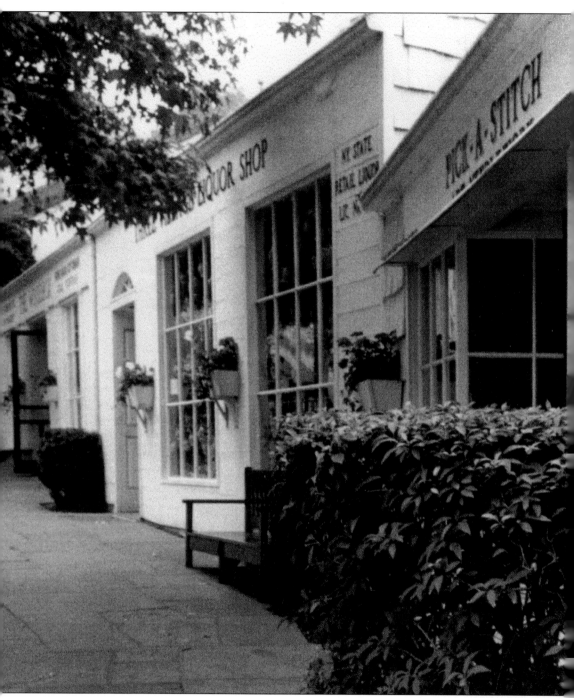

Visionary and philanthropist Ward Melville singly actualized the character, charm, and landscape for which the Three Village communities of Stony Brook, Setauket, and Old Field are renowned for today. He personally financed the restoration and preservation of dozens of historic sites in the area and the rehabilitation of Stony Brook's village center (above) and village green. Designed by architect Richard Haviland Smythe in 1940, the crescent-shaped shopping center provides panoramic views of Stony Brook Harbor. Melville held honorary memberships in several

esteemed organizations and served as chairman of the Council for the State University at Stony Brook, mayor of Old Field, and president of the Emma S. Clark Memorial Library. In 1997, the Stony Brook Community Fund, which he founded in 1939 for the purpose of maintaining Stony Brook Village, was renamed the Ward Melville Heritage Organization in his honor. (Courtesy of the Three Village Historical Society.)

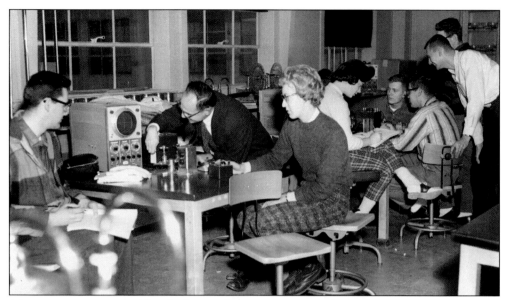

Administrators were served with the mandate to "prepare teachers of science and mathematics for secondary schools and community colleges." The mission of the university was expanded further in 1958, when additional programs in science, mathematics, and engineering were offered for the first time. By 1962, a liberal arts and sciences program and a graduate school were established on the campus.

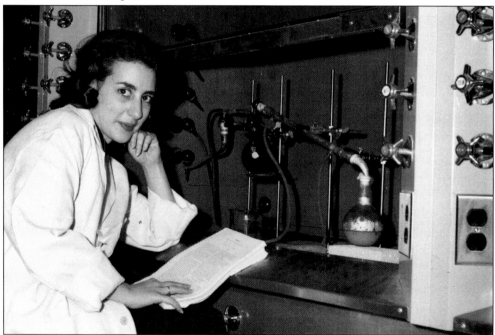

The undergraduate program in chemistry also served as a foundation for graduate level study. The curriculum focused on four fundamental courses required of all chemistry majors, which included one year of general chemistry, quantitative chemistry, organic chemistry, and physical chemistry, plus two semesters of advanced course work. Students were also required to take one year of physics and two years of mathematics.

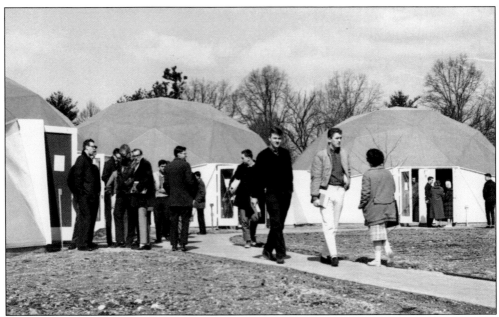

In an effort to accommodate the growing number of students at the Oyster Bay campus, 15 geodesic domes were installed within close proximity of Coe Hall. The identical shape and color of these structures often caused confusion. According to the 1962 edition of the *Specula*, "After six months, intelligent students and brilliant faculty members were often embarrassed by striding confidently into the wrong one of the semicircle of domes, or were very hesitant about their choice." The tops of the domes were later color-coded to denote their use: blue represented the bookstore and the student lounge, yellow represented classrooms, and red represented faculty offices.

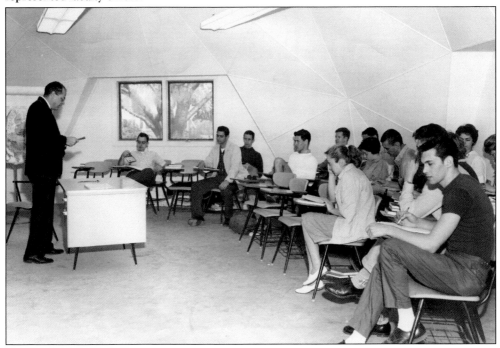

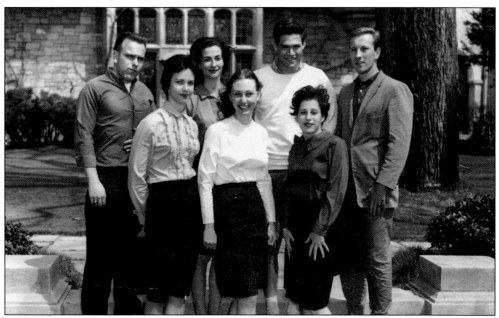

The Council for Political Inquiry provided students with a forum to study and discuss historical and contemporary political issues. This group sponsored several lectures, research projects, and field trips each semester. The lectures were diverse in subject matter, ranging from civil rights to the virtues of fraternities and sororities. Pictured, from left to right, are the following: (front row) Judy Paldy, Carol Kuncze, and Vivian Kahn; (back row) Fred Schubert, Sara Liebowitz, Mike Davidson, and Jim Kelly.

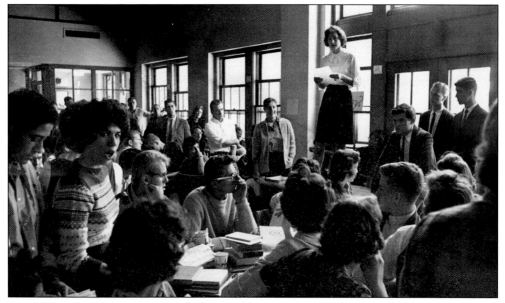

Several key administrators were transferred without explanation from the Oyster Bay campus to the State University of New York's administrative offices. Dr. Leonard Olson was assigned to a New York City office, and Allen Austill was relocated to SUNY headquarters in Albany. Although Austill retained his position as dean of students, these changes angered many students and consequently triggered the first on-campus demonstration.

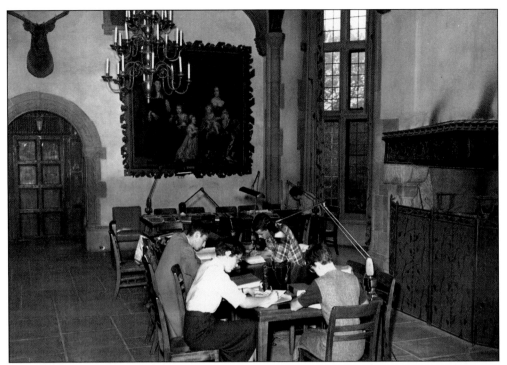

As enrollment at the Oyster Bay campus grew, administrators found it necessary to reallocate space within Coe Hall. The Coffee Shop, formerly the central meeting place on campus, was converted into a faculty lounge. Rooms that had formerly hosted dances, concerts, and chorus practice were now reserved as quiet study areas.

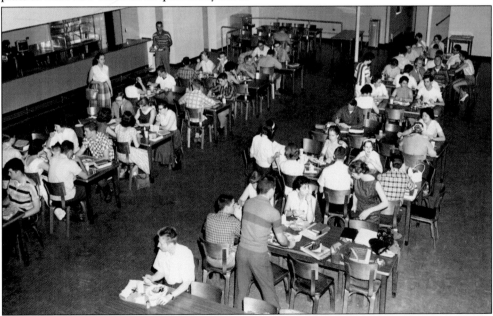

The loss of the Coe Hall Coffee Shop prompted students to adopt the new cafeteria as their center for social activity. Announcements and flyers soon adorned the walls, and clubs began to hold their weekly meetings here.

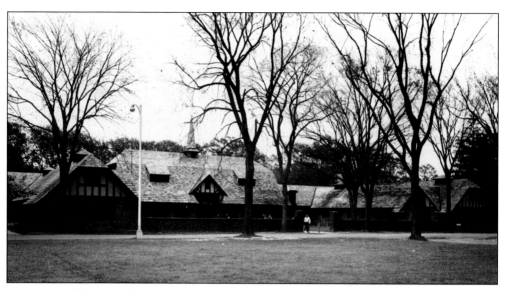

In the late 1950s, the State University of New York converted part of the original Haybarn, designed in 1918 by Walker & Gillette at the request of the Coe family, into a coeducational dormitory. Resident female students moved to the east wing of the stables in the spring of 1959. The new cafeteria separated the men's and women's wings. The cost for renovating and furnishing the dormitories and constructing the 280-seat capacity cafeteria was $670,000. This residence hall reached maximum occupancy by 1961, prompting male students to seek off-campus housing in nearby Bayville.

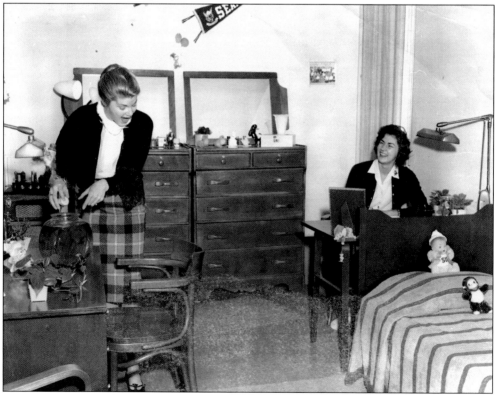

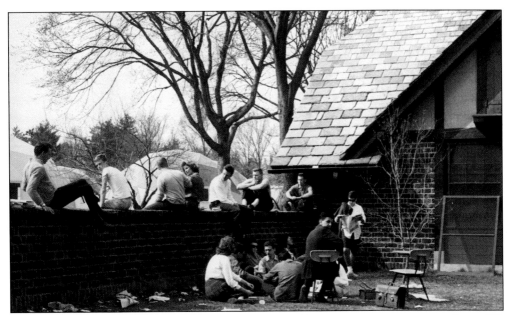

A limited number of classes and laboratories continued at the Oyster Bay campus for a fifth and final year. SUNY relinquished the property in 1970 to the New York Office of Parks and Recreation. As of 1978, the Planting Fields Foundation, with the assistance of the Coe family and in cooperation with the Office of Parks, Recreation, and Historic Preservation, has maintained stewardship of Coe Hall at Planting Fields Arboretum State Park.

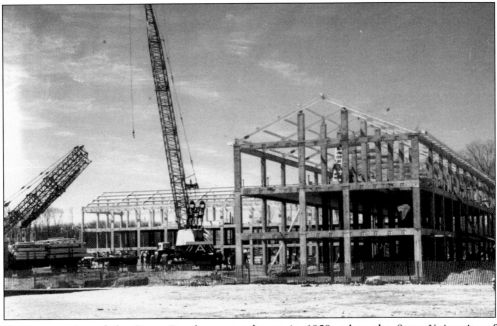

The preparation of the Stony Brook campus began in 1959, when the State University of New York embarked on $150 million building program. The first phase of construction included work on two academic buildings, one combined residence and dining hall, and a group of service buildings. The second expansion project focused on the construction of a library, biology and physics and engineering buildings, and a gymnasium.

Husband of my brothers piano teacher →

Dr. Thomas H. Hamilton was appointed as acting administrative head of the university in 1962. Trustees granted him the authority to "exercise the powers and perform the duties pertaining to the office of President of said Long Island Center until such time as a new incumbent of such office shall have been appointed." Hamilton resigned from SUNY in 1963 and later assumed presidency of the University of Hawaii.

Dr. Karl D. Hartzell was named executive dean of SUNY in 1962. He initially served as Stony Brook's chief administrative officer and acting dean of Arts and Sciences. Hartzell aspired "to create . . . traditions of intellectual inquiry and campus living which will enhance the professional reputation and foster the good name of our institution." He served as Stony Brook's chief administrative officer until his retirement in 1970.

The new Stony Brook campus opened on Sunday, September 16, 1962, for 780 students. A single corridor-style dormitory named G Dorm consisted of two wings connected by a cafeteria. A curfew was set for 10:30 p.m. for all students on weekdays, although on weekends women were required to be in their rooms by midnight and men by 1:30 a.m. This building also housed the administrative and faculty offices, the student newspaper, student government offices, and the infirmary.

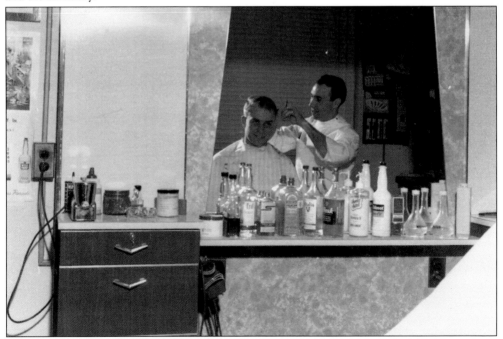

Pete's Barber Shop was a campus fixture in the early years of the university. In addition to managing his shop, Pete Mora (right) would often run errands for the students at the Oyster Bay campus. As a result, Mora decided to open a combination barbershop, dry cleaners, and grocery store when the campus moved to Stony Brook. His multipurpose shop was located in the basement of the A-wing in G Dorm.

Dr. Thomas F. Irvine, dean of Engineering, advocated for a new graduate program in engineering analysis, leading to the master of science degree. The university's expanded scientific mission necessitated the construction of a new engineering building, complete with additional laboratories and classroom space. This building also housed the university Computing Center and the specialized engineering library.

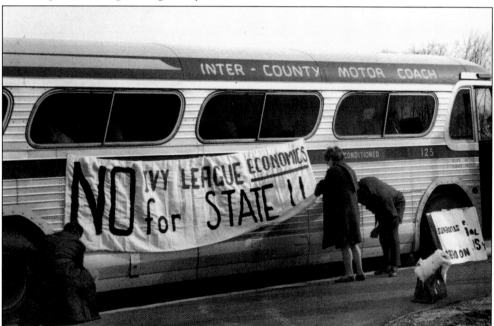

Stony Brook students united with other SUNY campuses in Albany seeking to restore the free tuition guarantee under the New York State Education Law. Two weeks prior to this demonstration, the state legislature had repealed this guarantee, and SUNY promptly announced a $400 tuition fee. The *Statesman* encouraged letter writing and petition campaigns, as a March extra edition stated, "It is your fight too . . . your future is at stake . . . protect it!"

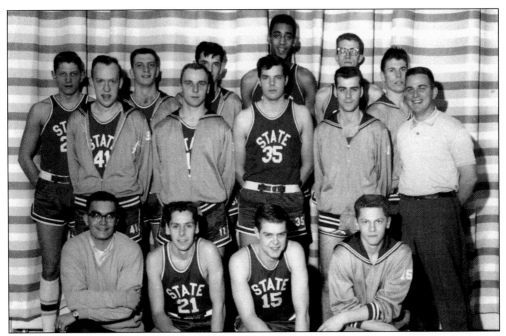

A. Henry Von Mechow, director of athletics, was a key figure in the development of school's athletic program. Both the crew and basketball teams had obtained varsity ranking by 1963. Pictured, from left to right, are members of the men's varsity basketball team: (front row) M. Levy, R. Vignato, J. Mattice, and R. Mancini; (middle row) D. Peas, W. Hlinka, B. O'Connor, P. Hertz, Coach Ferrell; (back row) G. Mitinas, R. LaRuffa, F. Baron, G. Tinnie, C. Tebbe, and E. Betker.

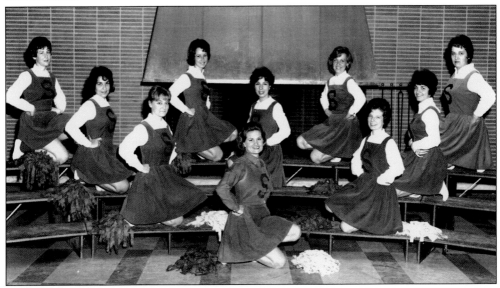

Intramural leagues continued to gain popularity, as students competed in table tennis matches and flag-football and softball games. Stony Brook's cheerleading squad was the first to win an award sponsored by a non-university organization. Pictured, from left to right, are members of the 1963 squad: (first row) B. Smith; (second row) K. Wiggand and P. Clarke; (third row) L. Levy, J. Kohn, and A. Mastromatteo; (fourth row) J. Savit, S. Dow, L. Kramer, and P. Latimer.

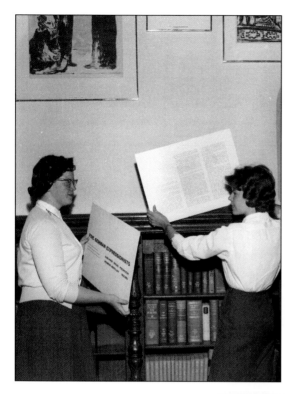

Polity, the student government organization, created Art, Music, Lectures, and Movie Subcommittees to promote cultural and educational events on campus. The Art Committee sponsored campus exhibits, field trips to the Museum of Modern Art and the Smithsonian, and student art contests and fairs. Pictured here are the two members of this subcommittee, Linda Dear (left) and Judy Slechta.

The campus radio station, WUSB, was first heard on the radio at 820 AM. The station played a wide array of music and featured a talk show called the *SB Round Table*. This program included interviews with faculty members and provided information about campus events. Today, WUSB (90.1 FM) is Long Island's largest noncommercial radio station and can be heard through most of Long Island, Southern Connecticut, and Brooklyn, Queens, and Westchester Counties.

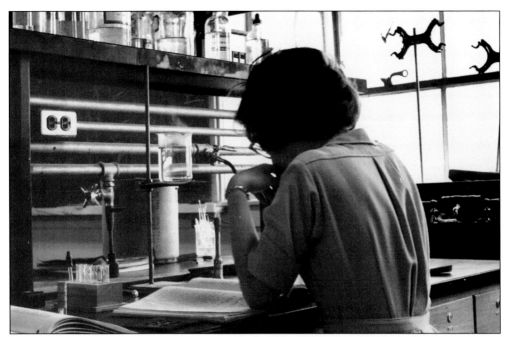

According to the 1961 *Bulletin*, every student was required to complete 16 laboratory hours and maintain a $5 deposit in the business office to cover laboratory equipment breakage. In an effort to support the university's expanded programs, the Biology, Chemistry, and Physics Departments held public seminars every two weeks. These well-attended events featured nationally recognized expert lecturers, who discussed a diverse array of scientific endeavors, ranging from Sputnik to the Salk vaccine.

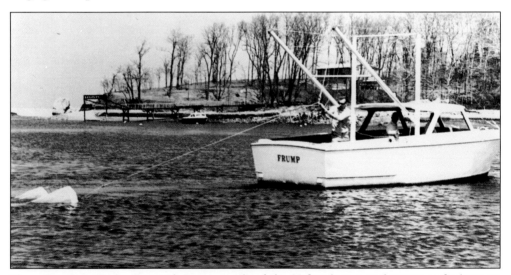

The university's Marine Research Division utilized the 28-foot-long vessel *Frump* to facilitate its scientific research. Dr. George C. Williams received a grant from the National Science Foundation to "investigate the relation of environmental factors to the egg and larval stages of fish, with the aim to discover new statistical techniques for explaining variations in plank communities." The SUNY Board of Regents designated Stony Brook as the Marine Science Research Center for the state of New York in 1965.

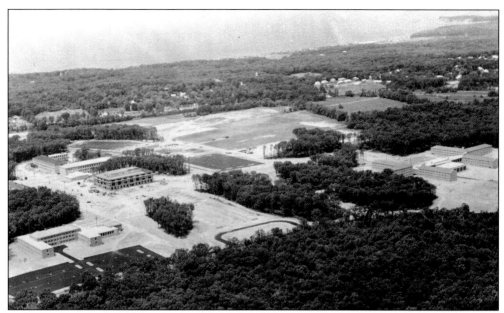

The university was rapidly expanding to meet the needs of its soaring enrollment. This early aerial photograph illustrates the swift construction of the campus. Work had begun on the engineering and biology buildings, the physical laboratory, and the library. The university now offered 232 courses within 14 academic departments in the College of Arts and Sciences and 30 courses under 4 departments in the College of Engineering. Some 1,000 students attended classes in the fall 1964 semester.

Although millions of dollars were invested in construction, equipment, and landscaping initiatives, wooden planks served as walkways throughout most of the new campus. The Stony Brook community had grown accustomed to the sight of red brick, steel, and cranes during the early phases of construction. The running joke among students was "If it couldn't be found in the Humanities or Chemistry building, it didn't exist."

The three-story Frank Melville Jr. Memorial Library offered students and faculty open stacks, 750 study carrels, and a music and projection room. The first-floor music library included sound equipment that was operated by "a music librarian and a skilled electronics engineer." The library's total holdings in 1963 consisted of 70,000 cataloged monographs, 1,500 periodicals, and 5,000 microfilm reels. The library also temporarily housed the university's business offices while the Administrative Building was under construction.

The new gymnasium complex featured an 1,800-seat indoor stadium, racquetball courts, exercise rooms, a dance studio, and an indoor swimming pool. The 25-yard, six-lap pool was open to the public when not in use by Stony Brook's athletic teams. This building also housed the Office of Physical Education and the Playhouse Theater. The 25-acre surrounding grounds included a track, baseball diamond, and tennis courts.

The
State University of New York
at Stony Brook
requests the honor of your presence
at the
Commencement Exercises
of
The Class of 1964
Sunday afternoon, June the seventh
two-thirty o'clock
at
The Campus
R. S. V. P.

Commencement exercises (the university's fourth) were held for the first time at the Stony Brook campus on June 7, 1964. Dr. David Fox, acting dean of the Graduate School, presented the university's first master of arts and master of science degree candidates. Following an address by Dr. Henry David of the National Science Foundation, Judge William J. Sullivan, council chairman of the State University of New York at Stony Brook, awarded the diplomas and presented the Ward Melville Valedictory Award. Dr. Karl D. Hartzell, chief administrative officer, conferred 120 degrees at the ceremony.

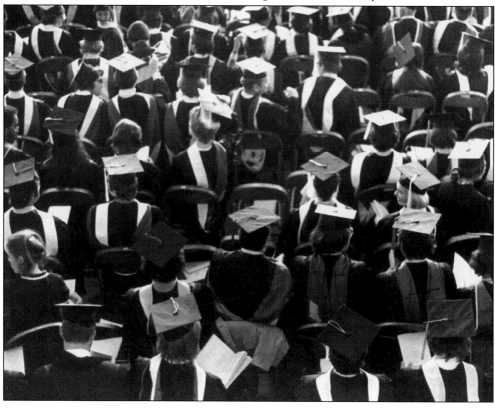

Three

UNPRECEDENTED
GROWTH AND EXPANSION

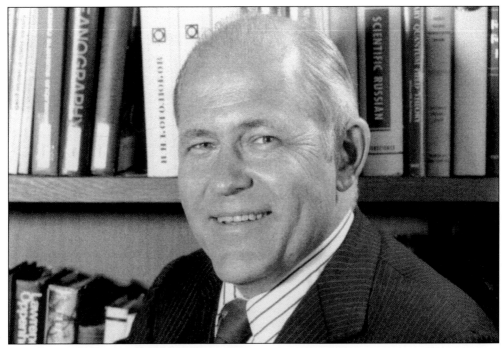

Dr. John S. Toll was inaugurated as the second president of the State University of New York at Stony Brook on April 1, 1965. Toll had formerly held the position of professor and chairman of the Department of Physics and Astronomy at the University of Maryland. During his 13-year tenure at Stony Brook, the campus experienced tremendous growth and development. Toll recruited elite researchers and scholars, including Nobel Prize recipient Dr. C.N. Yang, to develop competitive academic departments.

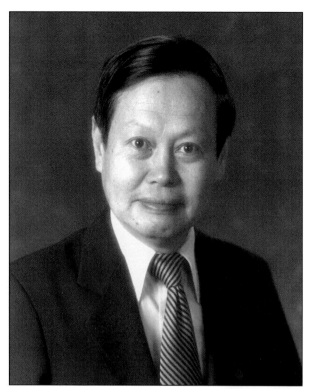

Dr. C.N. Yang was the first Nobel laureate to join the faculty at Stony Brook. He received the Nobel Prize in physics jointly with Dr. T.D. Lee of Columbia University in 1957. He was appointed by the SUNY Trustees as visiting distinguished professor of physics on May 12, 1965, and by the Board of Regents as Einstein distinguished professor of physics on November 12, 1965. Yang was chosen as the university's director of the Institute for Theoretical Physics in 1966, which was renamed in his honor in 1999. (Courtesy of the C.N. Yang Institute for Theoretical Physics.)

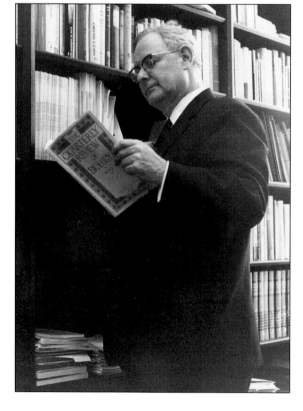

Dr. H. Bentley Glass, a world-renowned biologist, was appointed as the university's first distinguished professor of biology and as academic vice president in 1965. He served as president of the American Association for the Advancement of Science in 1968 while still in his second year as president of the United Chapters of Phi Beta Kappa. Glass is pictured holding a copy of the *Quarterly Review of Biology,* of which he was the associate editor from 1949 to 1957 and editor from 1958 to 1986.

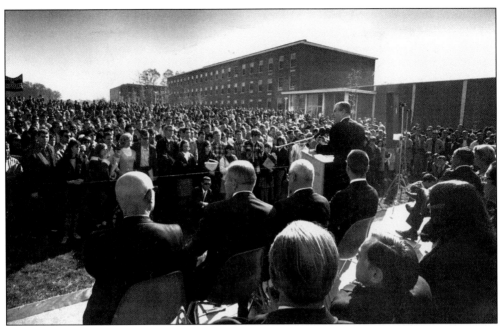

The university's high enrollment numbers were due in part to its early emphasis on scientific excellence. In an effort to accommodate 6,740 students, the campus embarked on a $50 million campus expansion plan, which included construction of an additional engineering building, a computing center, and an earth and space sciences building. Gov. Nelson Rockefeller, along with several thousand Stony Brook students, faculty, and staff, attended groundbreaking ceremonies on October 27, 1967.

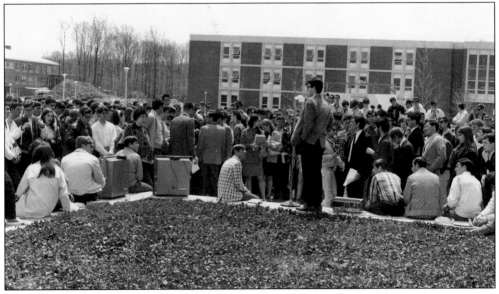

The campus community congregated on Library Hill for Action Wednesday, an event sponsored by the campus group Students for a Democratic Society. This rally featured two hours of speeches and discussions led by 20 faculty members and students. Topics addressed at this gathering included Vietnam and the draft, civil rights, and the politics of the Stony Brook campus.

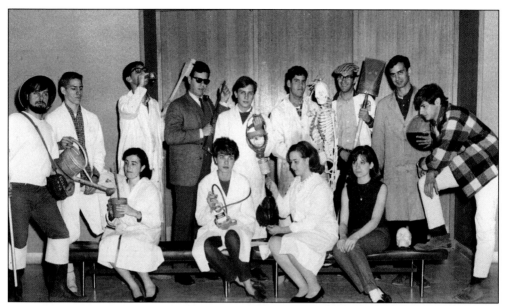

The Department of Biological Sciences continued to flourish under the chairmanship of Dr. Frank C. Erk. The graduate program focused on research in the three fields of molecular and cellular biology, genetic and developmental biology, and ecology and behavior. Pictured, from left to right, are members of the Biological Society: (front row) D. Mandel, M. Minor, J. Gerlitz, L. Schlessinger, and R. Malenky; (back row) T. Hilferty, R. Funch, W. Lehman, G. Krasilovsky, J. Kaplan, J. Weitzner, L. Kunstadt, and P. Levine.

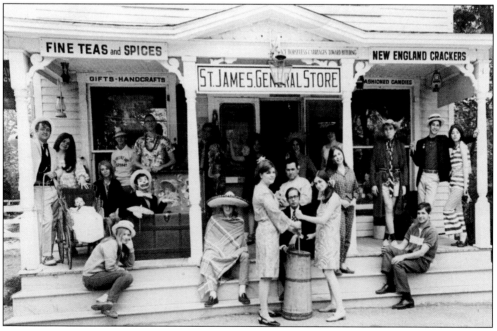

Performances held by the New Campus Theater Group were well attended by the community. These students acted in self-directed plays and traditional shows, including *A Child's Christmas in Wales* and *Shadow of a Gunman*. Members of the group are pictured in front of the local St. James general store, the oldest continuously operating general store in the United States.

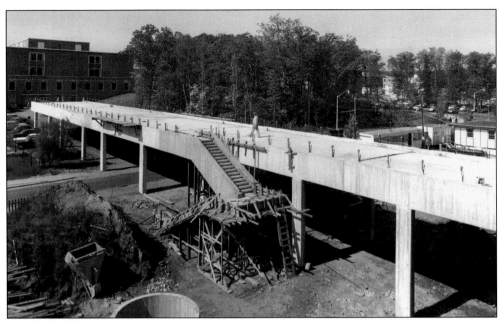

The construction of an overpass for Center Drive, which would connect the Student Union to the library, began in 1967. Budgetary constraints deferred the completion of this bridge for 10 years. As a result of the delay, the structure was referred to by the campus community as the "Bridge to Nowhere."

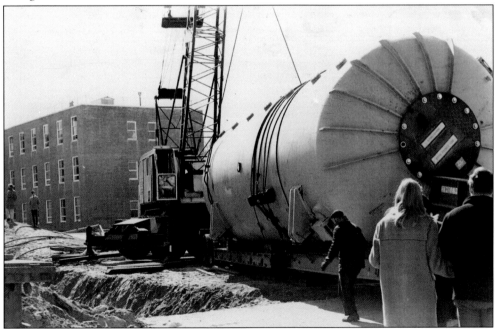

The nine-million-volt King Tandem Van de Graaff accelerator, a 44-foot-long, 57.5-ton atom smasher, was delivered to the Stony Brook campus on March 7, 1967. The university's Nuclear Structure Laboratory operates a "super-conducting linear accelerator, the first of its kind at any university in the world, for the production of heavy-ion beams with sufficient energy to create nuclear reactions with even the heaviest elements."

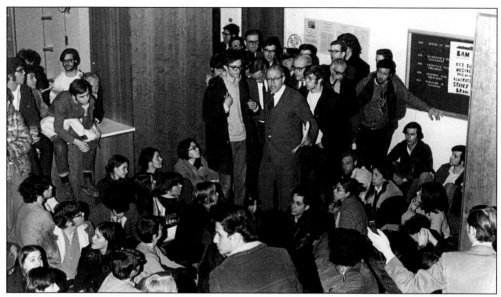

Some 500 students participated in an 18-hour protest outside the administrative offices of the library on March 12, 1969. The demonstration was prompted by the campus arrest of Mitchell Cohen, a former student with the status of *persona non grata*. Students for a Democratic Society presented Pres. John S. Toll with six demands, which included the abolishment of *persona non grata* status, military recruitment on campus, and war-related research. After three of the six demands were met, Toll officially closed the library. Campus officials requested the assistance of the Suffolk County Police after students ignored requests to vacate the building. A total of 21 students were arrested and charged with criminal trespass.

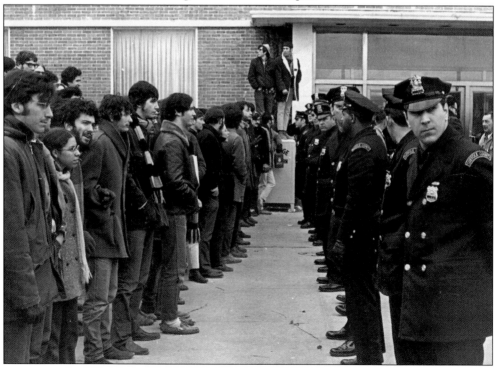

The Student Activities Board sponsored the university's annual Fall Festival. This event featured the sophomore-freshman challenge, in which the two classes competed against one another in basketball, volleyball, and dodge ball games. Theater skits and musical performances, which were held in the main lobby of G Dorm, attracted a large audience of students and faculty.

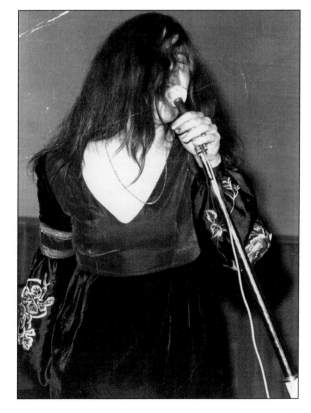

The Student Activities Board scheduled a series of summer concerts to raise money for the Long Island Farm Workers Service Center and to supplement its own budget. In the 1960s, crowds of over 17,000 convened at the university's athletic field for these concerts. Musicians who performed at Stony Brook include Janis Joplin (right), Pink Floyd, the Grateful Dead, Jimi Hendrix, and the Doors.

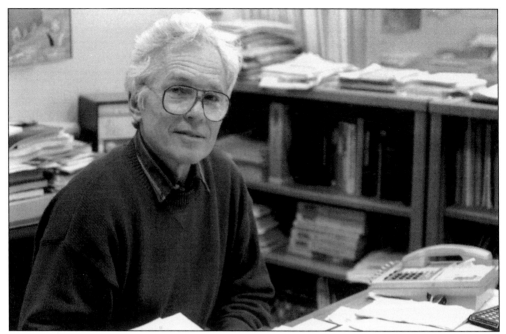

Dr. Charles E. Wurster, professor of biology and marine sciences and chairman of the Science Advisory Committee of the Environmental Defense Fund, led the scientific fight against the pesticide DDT. The organization's earliest headquarters were located in the Three Village area. The papers of the EDF were donated to the university in 1976 and are currently housed in the Special Collections Department of the Frank Melville Jr. Memorial Library.

Dr. Ashley Schiff, a conservationist, political science professor, and master of Benjamin Cardozo College, was known for his dedication to undergraduate education. Schiff developed the first credit-bearing course sponsored by a residence hall and was named "1 of 5 professors [who] meant the most" by both undergraduate and graduate students. The Ashley Schiff Preserve, located on campus south of Lake Drive and across from South Loop Road, was later established in his memory.

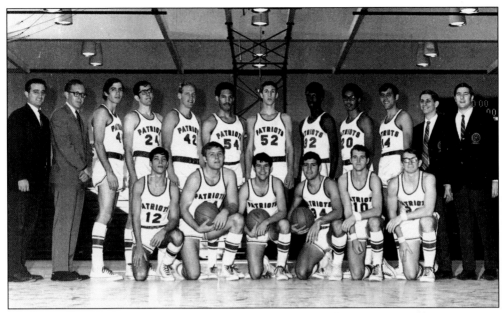

The men's basketball team finished its season with a record of 16-9. The team held its opponents to only 55 points per game, one of the best averages in the country. Pictured, from left to right, are the following: (front row) G. Glassberg, L. Neuschaffer, P. Garahan, M. Kirshner, P. Price, and F. McEwan; (back row) F. Tirico, H. Brown (coach), L. Landman, B. Friedman, G. Willard, M. Kerr, J. Phillips, G. Brown, D. Pruitt, B. Giekle, P. Molinari, and M. Weinstein.

The university hosted the eighth International Congress of Crystallography, one of the most prestigious scientific gatherings ever held on campus, in 1969. Stony Brook's prominence as a research university and its close proximity to Brookhaven National Laboratory made it an ideal site for the conference. More than 1,500 scientists, representing over 40 countries, attended the event. Major papers were presented in the Lecture Center Complex, including the first full analysis of the crystalline structure of insulin.

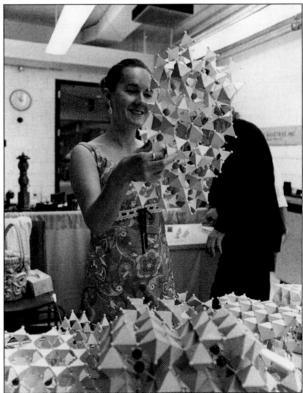

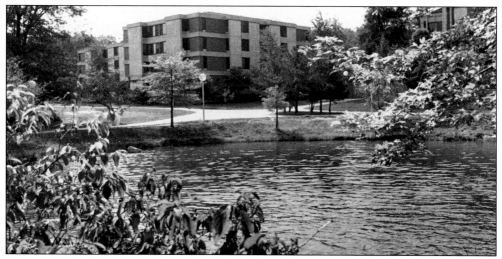

Students were now residing in the Roth Quad dormitories, although laundry facilities and telephone service were not yet available. In these suite-style residence halls, four to six students shared two or three bedrooms, a private bathroom, and a living or dining area. The five buildings comprising Roth Quad were named in honor of distinguished New Yorkers Benjamin Cardozo, Joseph Henry, Walt Whitman, George Gershwin, and William Sidney Mount. (Photograph by Maxine Hicks.)

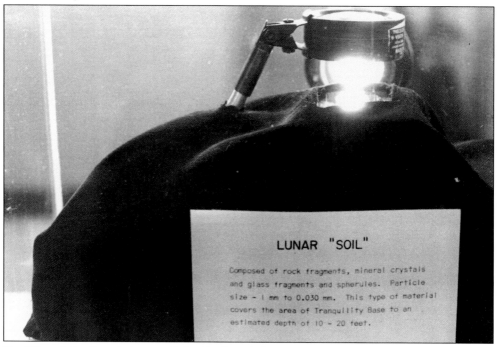

LUNAR "SOIL"

Composed of rock fragments, mineral crystals and glass fragments and spherules. Particle size - 1 mm to 0.030 mm. This type of material covers the area of Tranquility Base to an estimated depth of 10 - 20 feet.

Dr. Oliver Schaefer, chairman of the Earth and Space Sciences Department, was among the first scientists to date lunar rocks brought back to Earth by the Apollo 11 mission. The National Aeronautics and Space Administration (NASA) had granted Dr. Schaefer a contract to supervise the analysis of these moon samples. The university hosted an exhibit featuring the lunar rocks, which was attended by 3,000 visitors on opening day. The 12 grams of lunar material were valued at $12 million.

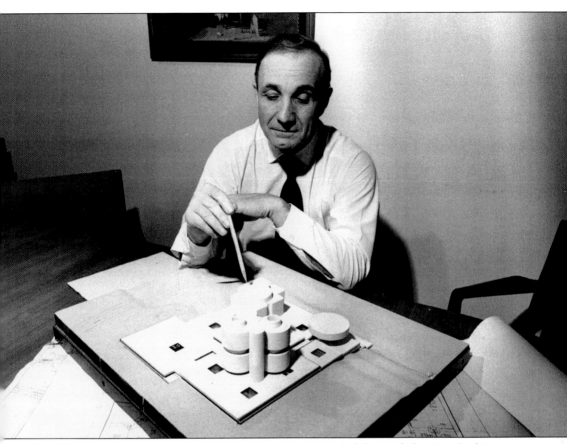

The 1963 Muir Report recommended to Gov. Nelson Rockefeller and the Board of Regents the establishment of a new medical center on Long Island. According to this report, the complex would include "schools of medicine, dentistry and other health professions on the State University campus at Stony Brook, Long Island by 1970." Dr. Edmund Pellegrino (pictured), a physician and medical philosopher, was appointed as vice president of the Health Sciences Center and dean of the School of Medicine. Prior to his appointment at Stony Brook, Pellegrino planned the first medical school programs at the University of Kentucky in Lexington and the Hunterdon Medical Center in New Jersey. He and Dr. Alfred Knudson, professor of medicine, began planning for "a revolutionary and foresighted institution, which would include five fields of specialization: medical research, clinical specialties, i.e. surgery and pediatrics, family medicine community medicine, and medical social sciences." In 1986, Stony Brook University's first endowed professorship in medicine was named in honor of Pellegrino. (Courtesy of Medical Photography.)

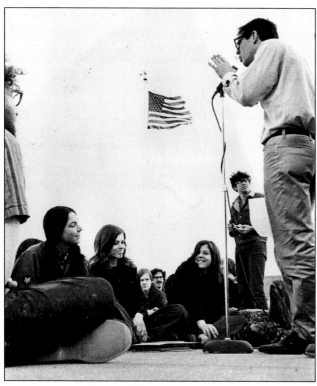

Students participated in an 11-day hunger strike against war-related research on campus in 1970. The strikers assembled in the Stony Brook Union under a banner that read "Fast as a peaceful protest against defense research on campus" and positioned themselves in the library lobby during the day and outside the building at night. Approximately 50 additional students participated in a "be-in," demonstrating their support by wearing black armbands and distributing water, vitamins, and medications.

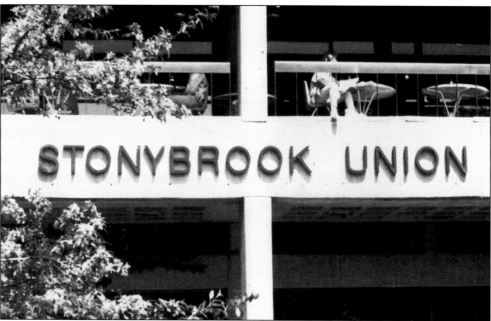

After seven years of construction, the Stony Brook Union opened in the fall semester of 1969. The building included meeting and conference rooms, a 600-seat ballroom, an art gallery, the campus radio station WUSB 90.1 FM, and offices for the university's student organizations. It also served as the center of social activity, as it included a 24-hour snack bar, an arcade, a bowling alley, a crafts center, and a beauty parlor. (Courtesy of the *Statesman*.)

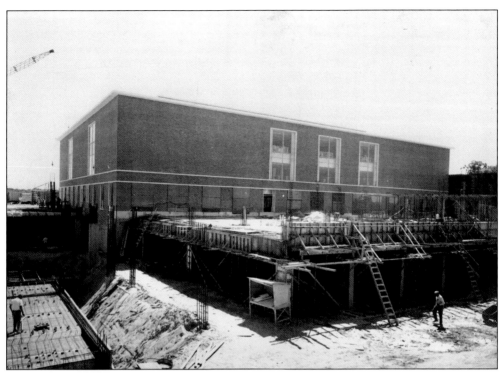

The Frank Melville Jr. Memorial Library, named in honor of Ward Melville's father, reopened in 1971 after a major expansion. The project, which took two years to complete, entailed incorporating a larger structure around the perimeter of the existing library. Today, the university libraries provide state-of-the-art information services and house nearly two million bound volumes.

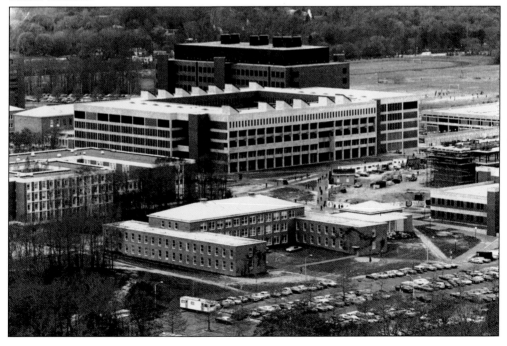

The 1970–1971 men's squash team was ranked 10th nationally, as standouts Stuart Goldstein and Chris Clark provided the team with crucial victories. The team won its third straight Metropolitan Championship the following year. Stuart Goldstein (Class of 1973) personally attained a seventh ranking nationally and was Stony Brook's first athlete to earn All-American honors.

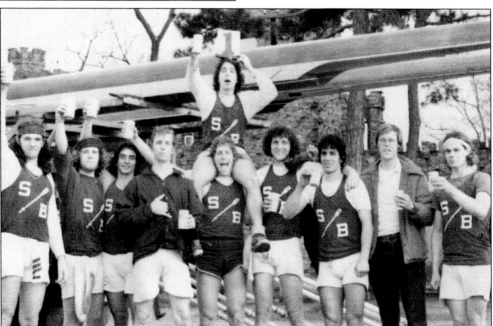

The Stony Brook crew team practiced in Conscience Bay and Mount Sinai Harbor before finally settling at Port Jefferson Harbor (Poquott) in the spring of 1972. The team experienced great success despite lacking a permanent boathouse and adequate equipment. The 1976 varsity team went undefeated and won the Metropolitan Championship under the direction of head coach Paul Dudzick. The Stony Brook crew program was reinstated in the spring of 1997, after a 20-year absence. (Courtesy of Paul Dudzick.)

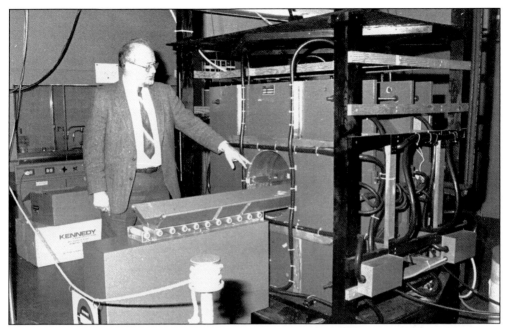

Dr. Paul Lauterbur, professor of chemistry, produced the first image of a living organism via nuclear magnetic resonance in 1973. He is pictured here with the original red nuclear magnetic resonance imager he developed in the Graduate Chemistry Building. Lauterbur is currently the director of the Biomedical Magnetic Resonance Laboratory, a division of the Department of Medical Information Science at the University of Illinois.

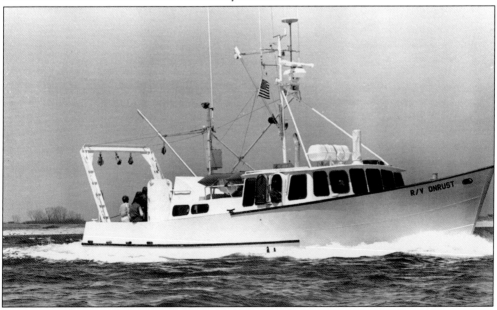

Trustees named the Marine Sciences Research Center (MSRC) as the State University of New York's center for marine research, graduate education, and public service. Deborah Toll, wife of Pres. John Toll, christened the facility's 55-foot-long research vessel, R/V Onrust, at the Stony Brook Yacht Club in 1975. This vessel was recently retired by the Marine Sciences Research Center after 25 years of service.

The Health Sciences Center's Schools of Allied Health Professionals, Basic Health Sciences, Social Welfare, Nursing, and Medicine began offering classes by 1971. The School of Dental Medicine opened in 1972 with 24 students, selected from a pool of more than 1,600 applicants. Classes were held in temporary facilities on the South Campus, while the architectural firm of Bertrand Goldberg Associates, designers of the famed Marina City Towers in Chicago, planned a comprehensive Health Sciences Center on the East Campus. The Health Sciences Center's first deans gathered at the complex's 250-acre future site in 1975. Pictured, from left to right, are Dr. Edmund J. McTernan, School of Allied Health Professions; Dr. Max Schoen, School of Dental Medicine; Dr. J. Howard Oaks, vice president of the Health Sciences Center; Dr. Ellen T. Fahy, School of Nursing; Dr. Marvin Kushner, School of Medicine; Dr. Arthur Upton, School of Basic Health Science; Dr. Leonard Levy, Podiatric Medicine; and Dr. Sanford J. Kravitz, School of Social Welfare.

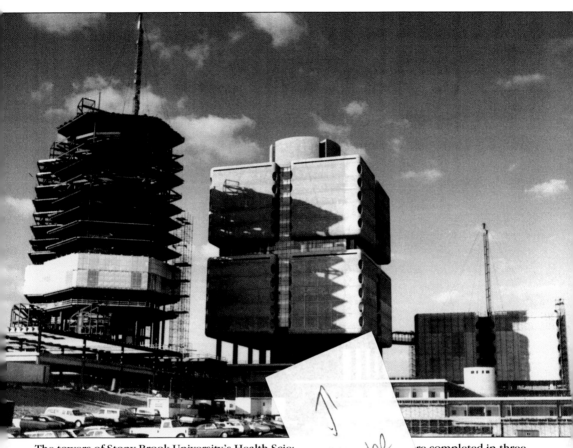

The towers of Stony Brook University's Health Scie[...]re completed in three stages between 1976 and 1980. The Clinical Scienc[...]d in 1976, followed by the Basic Health Sciences Research Tower (righ[...]n on the 19-story, 540-bed University Hospital (left) was not finished[...]ices and research laboratories, located in the Clinical Sciences Tower, c[...]via a sixth-floor glass encased bridge. The construction cost of the Heal[...]plex amounted to approximately $300 million. Today, the Health Science[...]of the Schools of Dental Medicine, Health Technology and Management, M[...]ocial Welfare, and the Long Island State Veterans Home.

can be seen from CT on a clear day!

The urban and policies program, founded in 1970, was renamed the W. Averell Harriman School for Management and Policy, after New York State's former governor. Harriman (third from right) was the guest of honor at the school's dedication ceremonies. The Harriman School offers several programs leading to undergraduate and graduate degrees in business and management.

William Butler Yeats (1865–1939), the prominent Irish poet and playwright, was awarded the Nobel Prize for literature in 1923. The William Butler Yeats Microfilmed Manuscripts Collection was acquired from the Yeats family in December 1974. This collection, housed in the Special Collections Department, represents the most extensive collection of Yeats's material outside of Ireland. In 1976, the university hosted a William Butler Yeats Festival in celebration of the collection.

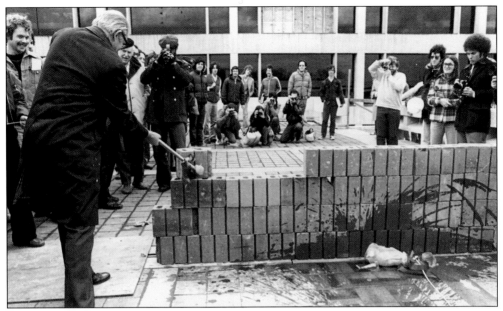

After 10 years of construction, the "Bridge to Nowhere" was dedicated on November 11, 1977. The Honorable H. Lee Dennison, former Suffolk County executive, served as master of ceremonies at the event, which featured performances by the University Band Trumpet Ensemble. Pres. John Toll (with the sledgehammer) participated in the wall-breaking portion of the ceremony. The completed bridge measures 30 feet wide and 475 feet long and connects the library and Fine Arts Building to the Student Union.

New York Gov. Hugh Carey (left) presided over the 1978 ribbon-cutting ceremony at the Museum of Long Island Natural Sciences, housed in the Earth and Space Sciences Building. Also in attendance were T. Alexander Pond (center), acting president of the university, and Steven Englebright (right), the museum's founder and former curator. Englebright was elected to public office in 1982 and today serves as state assemblyman for New York's 4th Assembly District.

Phase I of the Fine Arts Center, which includes classrooms, offices, rehearsal halls, and an art gallery, opened in 1975. Phase II, completed in 1979, houses an experimental theater program consisting of two black-box theatres, a 1,200-seat concert hall, and a recital hall. The Fine Arts Center was renamed the Staller Center for the Arts in 1988.

Dr. Thomas Flanagan (right), professor of literature, began his tenure in the English Department at Stony Brook University in 1978. His first novel, *The Year of the French*, was named "Outstanding Work of American Fiction" by the National Book Critics Circle in 1979. This trilogy included *The Tenants of Time*, published n 1988, and *The End of the Hunt*, in 1994. Flanagan is pictured at a campus book-signing event in support of *The Tenants of Time*.

Four

A RESEARCH UNIVERSITY EMERGES

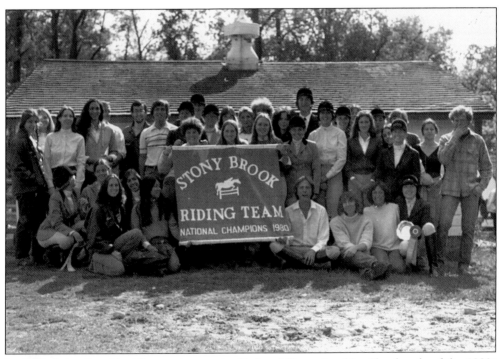

In 1980, Stony Brook's riding team won the National Championship. The decade of the 1980s was a big one for sports at the university. The Patriots women's volleyball team won the 1982 New York State Division III championship, the first women's state title for the university. Also during that time, Stony Brook athletes won All-American honors in squash, swimming, football, and cross-country, and ended the decade with Division I entry for women's soccer and men's lacrosse in 1989.

Dr. John H. Marburger III became Stony Brook's third president in 1980. During his 14-year presidency, Stony Brook opened University Hospital, developed a national reputation for work in the biological sciences, and emerged as a world-class institution. In 1997, Marburger, who served on the gubernatorial commission on the Shoreham Nuclear Plant, became president of Brookhaven Science Associates, which was awarded the contract to manage Brookhaven National Laboratories. In 2001, Pres. George W. Bush appointed Marburger as director, Office of Science and Technology Policy.

Dr. Sidney Gelber, distinguished service professor and leading professor of philosophy emeritus at Stony Brook, served both as university provost and academic vice president. Prior to assuming his position as provost in 1971, Gelber served as associate dean for the College of Arts and Sciences, worked in the Regional Planning Office of Fine Arts and Humanities, and served as professor of philosophy and chairman of the Department of Philosophy. He retired as provost in 1981.

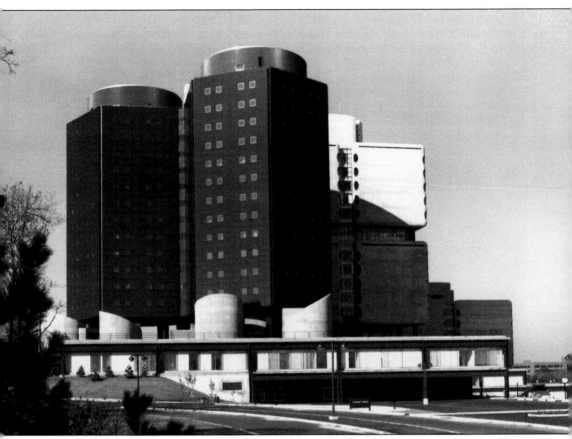

In February 1980, Stony Brook University Hospital, the first major teaching hospital established in the United States since 1977, opened 30 beds and an Ambulatory Care Pavilion. As a result, Stony Brook became the first university center in the SUNY system to operate a medical center. The hospital provided a full spectrum of health care services, from primary preventive care to the highest levels of specialized health care. Stony Brook serves as a regional referral center for burn and cancer care, high-risk obstetrics, neonatal intensive care, kidney transplants, open-heart surgery, and severe trauma cases. The facility includes a 504-bed hospital, a 350-bed nursing home, and a Dental Care Center. In 1998, University Hospital was named in a national study that examined 3,575 hospitals as one of the top 15 teaching hospitals in the United States and as one of the 100 best hospitals. In the year 2000, a total of 13 Stony Brook University Hospital and Medical Center physicians were featured in the *New York Magazine*'s cover story "The Best Doctors in New York." (Photograph by Medical Photography.)

The State University of New York at Stony Brook presents the

BACH ARIA FESTIVAL
AND
INSTITUTE AT STONY BROOK

The first Bach Aria Festival and Institute was held on the campus of Stony Brook University in 1981. This annual event, headed by music faculty member Samuel Baron, brought outstanding young performers together with Bach specialists and leading interpreters of the Baroque style. The two-week program, which offered master classes, rehearsals, and public performances of solo, chamber, instrumental, and vocal works, was discontinued in 1997.

The first Island Convention of Science Fiction, Fact, and Fantasy (I-CON) was held at Stony Brook in 1981 and has been an annual tradition ever since. Dealer Tom Scheur (in costume) is pictured at the convention, which features a wide assortment of lectures, awards, science fiction movies, and panel discussions with renowned science fiction writers, artists, comic book editors, and scientists. The event attracts thousands of science fiction devotees, many in costume. (Photograph by Maxine Hicks.)

Stony Brook's *Zebra Path* was designed and hand-painted by student-artist Kim Hardiman as part of a public art seminar in 1981. Funding for the path came from a $1,000 campus beautification grant, which Hardiman shared with five other students. The distinctively painted 232- by 12-foot walkway leads from the old chemistry building to the new graduate chemistry building on the university's main campus, and is easily the most recognizable path at Stony Brook.

In 1981, U.S. Sen. Jacob K. Javits donated his public papers to Stony Brook. The documents (over 2,000 cubic feet of material) cover his 34 years of public life. A ceremony was held in 1983 to award Javits the University Medal, announce the opening of the Javits collection for scholarly research, and dedicate the Javits Reading Room. Seven U.S. senators, Gov. Mario Cuomo, and local political figures attended the ceremony. (Photograph by Medical Photography.)

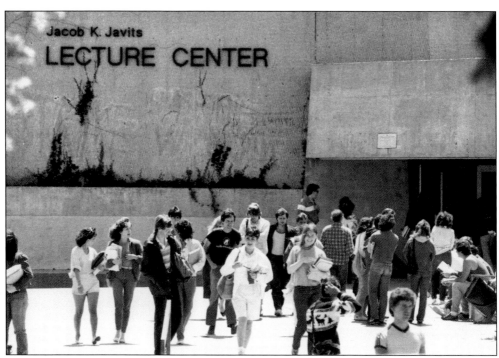

In April 1984, at the suggestion of a *Statesman* student editor, the Lecture Center was renamed the Jacob K. Javits Lecture Center in honor of the senator's many contributions to education and Stony Brook. Javits, who died in 1986, served New York State as attorney general, four terms in the U.S. House of Representatives, and four terms in the U.S. Senate. (Photograph by Lou Manna.)

In 1980, Dr. Felix Rapaport (center) was honored with the French *Grand Croix des Palmes-Academiques* for his work in histocompatibility, which laid the groundwork for human organ transplantation. Founder of the Division of Transplantation, professor of surgery, and director of transplantation services at University Hospital, Rapaport worked in collaboration with Jean Dausset, the 1980 Nobel laureate for medicine and physiology. Rapaport is pictured conferring at University Hospital. (Photograph by Medical Photography.)

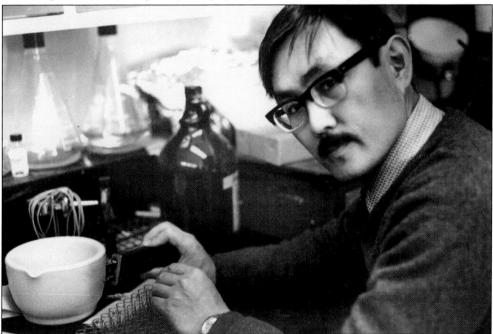

Dr. Masayori Inouye, Stony Brook biochemistry professor, in 1983 was the first to discover natural antisense RNA, a key to genetic control of life processes. Inouye was associate professor of biochemistry at Stony Brook from 1971 to 1975, chair of the molecular biology program from 1975 to 1977, and professor of biochemistry from 1977 to 1986. He organized the first six Stony Brook Symposiums. He is currently professor and chair of the biochemistry department at the Robert Wood Johnson Medical School in New Jersey.

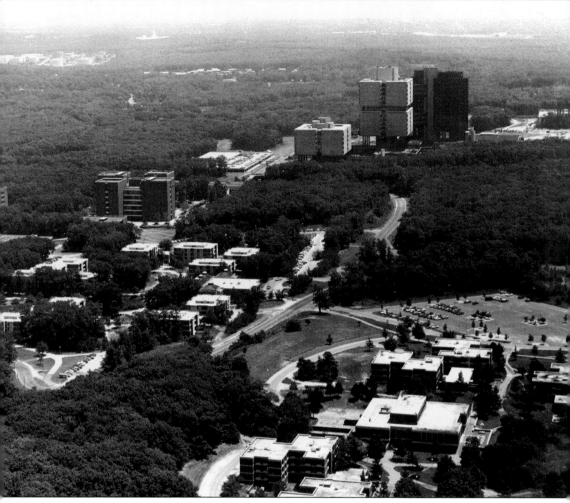

This 1983 view of Stony Brook illustrates the growth and impact of the university after only 25 years. By 1983, the Health Sciences Center and University Hospital had been built, and the university complex included many additional buildings. The hospital and center can be seen in the upper right of the photograph. The large building to the left is Life Sciences, and to the left of Life Sciences is the Social and Behavioral Sciences Building. Stony Brook's residential quadrangles are in the lower right. The campus had expanded to include 98 buildings on 1,000 acres. Faculty members numbered 1,100, and the number of students at Stony Brook in 1983 was over 16,000 (11,000 undergraduates and 5,000 graduate students). Located about 60 miles from New York City, Stony Brook's vital academic community is situated in a suburban setting not far from Long Island's rich farmland to the east, and only a few minutes from the Long Island Sound to the north. (Photograph by Medical Photography.)

Stony Brook's dynamic and productive faculty members have received recognition from national award-granting agencies on many occasions. Awards have included Guggenheim Fellowships, the Fields Medal, the Pulitzer Prize, Alfred P. Sloan Fellowships, MacArthur Fellowships, fellowships from the National Endowment for the Humanities, Fulbright Fellowships, and Presidential Young Investigator Awards. Assorted faculty and staff members are pictured in this 1986 photograph. (Photograph by Medical Photography.)

Dr. Margot Ammann (front, second from left), daughter of the Swiss-born engineer who built the Golden Gate Bridge, Othmar Ammann, established a scholarship at Stony Brook in her father's name. She maintained her family's commitment by increasing the Ammann endowment and funding improvements in Ammann College, the G Quad residence hall named in her father's honor. Seated with Ammann are scholarship recipients Dr. Egon Neuberger (third from left), vice provost; and Carole G. Cohen (right), vice president for university affairs. (Photograph by Kenneth Wishnia.)

Grumman Corporation, a Long Island defense contractor, donated $100,000 to Stony Brook University Hospital for the purchase of a 28-foot, custom-designed mobile intensive care ambulance. Officials at University Hospital joined Grumman representatives at the dedication and tour of the new ambulance. The high-tech unit, about the size of a mobile home, was capable of transporting up to three critically ill patients and a team of medical personnel. Stony Brook professor Les Palder's engineering class visited Grumman's manufacturing facility for a tour in 1985. Grumman won the contract to build two X-29 forward-swept wing research planes in 1981.

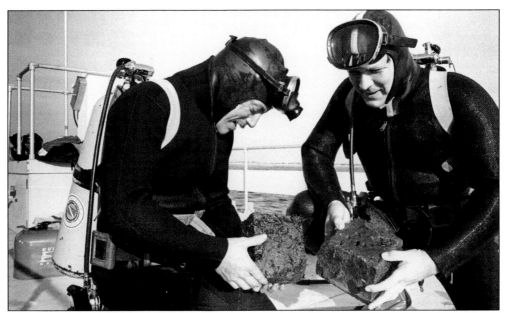

Jeffrey Parker (left) and Dr. Frank Roethal, researchers of the Marine Sciences Research Center at Stony Brook, examine samples of an artificial fishing reef built of stabilized ash in 1988. A leading academic institution for the study of marine and atmospheric issues, the center received a $1 million New York State grant in 2000 for a marine pathology laboratory to investigate marine diseases, particularly those affecting the Long Island lobstering industry. (Photograph by Bob Klein.)

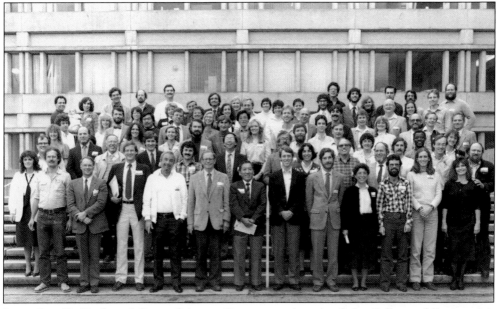

Stony Brook's Earth and Space Sciences Department is part of the College of Engineering and Applied Sciences and is located in the same building that houses the Museum of Long Island Natural Sciences and a rooftop observatory. The field of earth and space sciences is multidisciplinary, combining astronomy, geology, atmospheric science, and marine science. Pictured in 1985 are department faculty members. (Photograph by Medical Photography.)

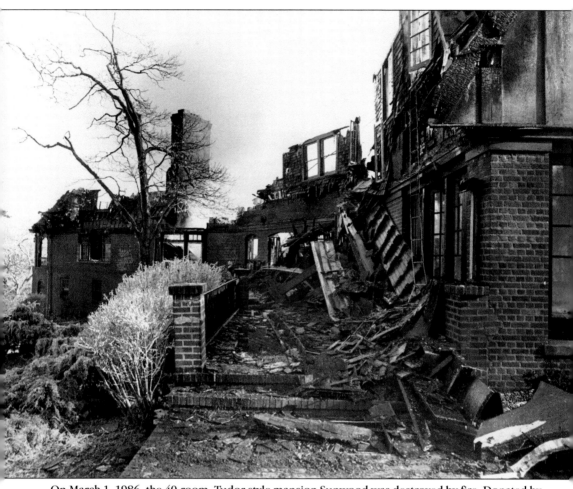

On March 1, 1986, the 40-room, Tudor-style mansion Sunwood was destroyed by fire. Donated by Ward and Dorothy Melville for use by the university administration, the mansion on Mount Grey Road in Old Field served as Stony Brook's conference center, guest facility, and faculty retreat. It hosted many programs, including conferences, concerts, and university social events. Its 27 acres of gardens and beautiful beach, only 10 minutes from the Stony Brook campus, continued to be used by the university for picnicking and swimming. In 2002, Sunwood was rebuilt as a conference center and presidential residence. The new two-story building was designed to be used for Stony Brook Foundation fund-raising efforts, entertainment, and special university events. Architectural features include a stair tower and decorative wood trusses evocative of the original estate. (Photograph by Robert O'Rourk.)

The social and behavioral sciences building (below), originally opened in 1978, was renamed in honor of Ward Melville in September 1987. Melville gave generously to the university and worked to preserve the historical character of Long Island. His donation of 480 acres of land in 1960 made the development of the Stony Brook campus possible. Attending the dedication ceremony and plaque unveiling are, from left to right, Dr. Jerry K. Schubel, provost; Dr. Karl Hartzell, keynote dedication speaker and retired administrator; Margaret Blackwell, daughter of Ward Melville; and Pres. John Marburger.

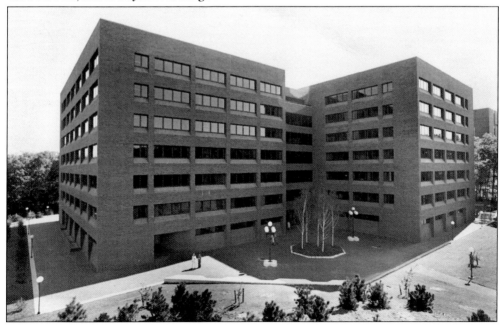

Campus living in the 1980s included midnight fire drills, all-night cramming sessions, sports events, Hawaiian and toga parties, Fall Fest, G-Fest, Octoberfest, Rothfest, Tablerfest, late-night fast-food runs and, of course, graduation. A new alcohol policy was instituted with the raising of the legal drinking age to 21. In 1994, Pres. Shirley Strum Kenny accelerated Stony Brook's refurbishing of campus residence halls with an $80 million project that renovated all 26 residence halls on campus, constructed a 500-bed apartment-style housing complex, and transformed Stony Brook's residential environment into one of the premiere college housing programs in the nation. (Photograph by Medical Photography.)

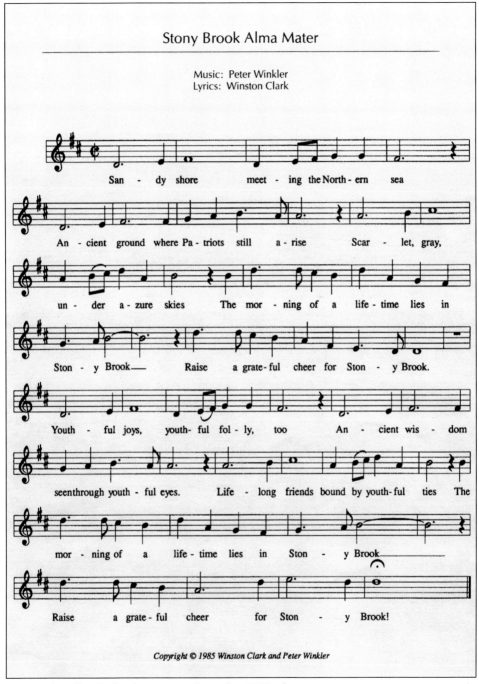

Stony Brook Alma Mater

Music: Peter Winkler
Lyrics: Winston Clark

San - dy shore meet - ing the North - ern sea
An - cient ground where Pa - triots still a - rise Scar - let, gray,
un - der a - zure skies The mor - ning of a life - time lies in
Ston - y Brook— Raise a grate-ful cheer for Ston - y Brook.
Youth - ful joys, youth- ful fol - ly, too An - cient wis - dom
seenthrough youth - ful eyes. Life - long friends bound by youth-ful ties The
mor - ning of a life - time lies in Ston - y Brook
Raise a grate - ful cheer for Ston - y Brook!

Stony Brook's official school song was adopted in 1985, after a contest to compose an appropriate alma mater was held. Collaboration between Winston Clark and Dr. Peter Winkler resulted in the winning submission. Winkler, using a melody that slowly unfolds upward and descends in a stirring and grand manner, set Clark's warm and evocative lyrics to music. Carol Marburger, wife of Pres. John Marburger, is credited with being the guiding spirit behind the alma mater. (Copyright 1985 Winston Clark and Peter Winkler.)

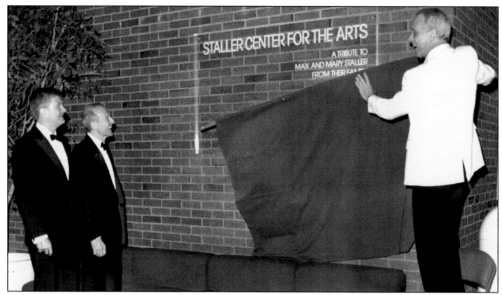

In 1988, the Fine Arts Center at Stony Brook was renamed the Staller Center for the Arts in honor of late real estate mogul Max Staller and his wife Mary Staller. The Stallers, longtime supporters of the arts center, gave Stony Brook $1.5 million dollars for fine arts programs and building maintenance. Attending the formal dedication in 1989 are, from left to right, Pres. John Marburger, Erwin Staller, and Dr. Terrence Netter, the director of the arts center. (Photograph by Barbara Mooney.)

In 1986, the campus Barnes and Noble bookstore moved from the Student Union to a larger facility in the basement of the Melville Library. The move allowed the bookstore to operate on one level and to carry a larger selection of material, including new and used books, campus living supplies, clothing imprinted with the Stony Brook logo, gift items, and greeting cards. Pres. John Marburger attended the ribbon-cutting ceremony.

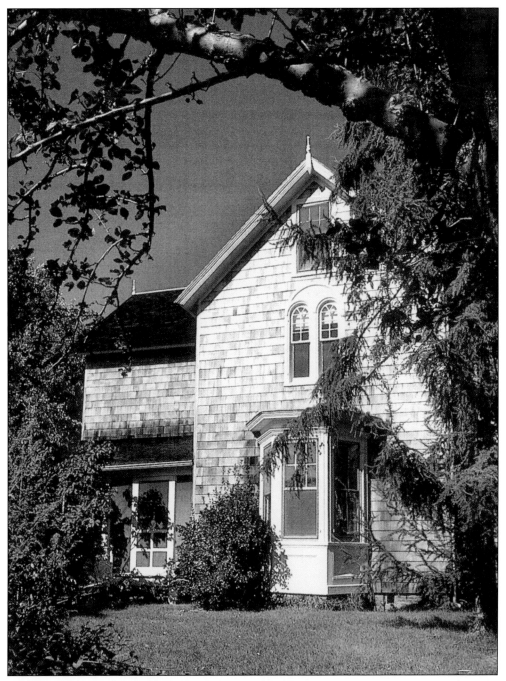

The late-19th-century Pollock-Krasner House, outbuildings, and grounds were deeded to the nonprofit Stony Brook Foundation in May 1987. The foundation will preserve and develop this East End National Historic Landmark, originally the home and studio of Jackson Pollock, leader of the Abstract Expressionist movement. The Study Center at the house contains an art reference library, documentary archives, and collections of audio and videotapes and photographs. Lectures, art exhibitions, and courses are offered at the center. (Courtesy of Pollock-Krasner House and Study Center.)

Dr. Patricia Wright (foreground), Stony Brook anthropology professor and director of the Institute for the Conservation of Tropical Environments, was the first scientist to identify the golden bamboo lemur (*Hapalemus aureus*), a previously unknown species, in 1986. Wright won a MacArthur Fellowship in 1989 and donated the entire $500,000 award to create the Ranomafana National Park in Madagascar. This park provides a protected habitat for lemurs and thousands of other rainforest animals, and prevents exploitative timbering. Pictured are faculty members of Stony Brook's Anthropology Department (below), which encompasses the subdisciplines of social anthropology, archaeology, and physical anthropology. (Above photograph by Janice Levy, all rights reserved.)

Each Tuesday from May through September, Stony Brook's Student Activities Center bus loop turns into an old-fashioned farmers market, sponsored by the Faculty-Student Association. This 1986 photograph illustrates how local residents, faculty, staff members, and students come to the market to browse through and purchase fresh produce, specialty breads, fresh flowers, and homemade jams, jellies, preserves, pies, and other sweets. (Photograph by Medical Photography.)

Stony Brook graduate students, protesting the lack of affordable housing, set up a tent city in the center of the Academic Mall in April 1987. A work stoppage by the graduate teaching assistants canceled classes, labs, and plenary sessions for two days and culminated in a huge Graduate Student Organization (GSO) rally on April 8. Demands included an increase in the graduate student stipend, lower childcare rates, health plans, and the right to unionize.

To raise awareness of the special needs of disabled persons within its community, Stony Brook declared Able/Disabled Week in April 1989. Accessibility was increased through the installation of automatic doors, lowered drinking fountains, and ramps throughout the campus. Stony Brook's Office of Disabled Student Services offers tutoring and testing for learning-disabled students on campus.

Stony Brook's participation in the SEFA-United Way campaign has raised considerable sums of money over the years. Payroll deducted or direct contributions are tallied on a thermometer, which is placed in a prominent location on campus so the Stony Brook community can monitor the progress of the campaign. Pres. John Marburger (left), chair of the State Employees Federated Appeal (SEFA) campaign, is congratulated by Jack Sage, president of United Way of Long Island.

Five

INNOVATION
AND EXCELLENCE

Stony Brook's annual Roth Pond Regatta began in 1987. Student-faculty teams are challenged with constructing a seaworthy vessel (no larger than 20 feet by 6 feet) from nothing but cardboard and duct tape. The race begins at one end of the pond and ends when the first boat crosses the finish line without sinking. Two categories of boats, speedsters (one-person) and yachts (two-person), race in elimination heats until a winner is declared in the final round.

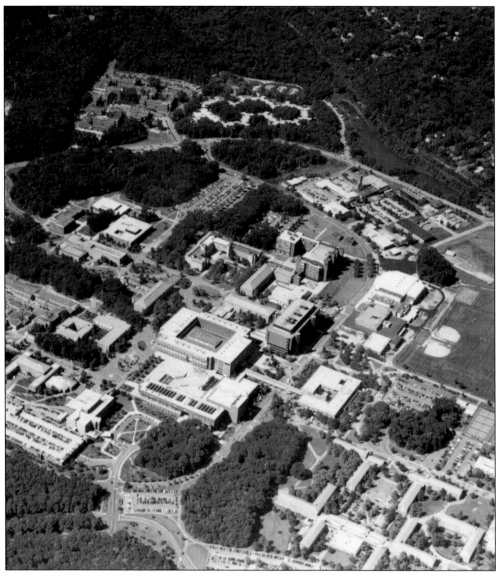

This aerial photograph of the Stony Brook campus, looking northwest, was taken in July 1990. The campus experienced enormous expansion during its first decades. The university and hospital complexes now covered more than 1,100 acres and employed over 9,000 people. In 1991, Stony Brook enrolled more than 17,000 students and had over 1,500 faculty members. University Hospital's 504 beds served more than 200,000 patients that year.

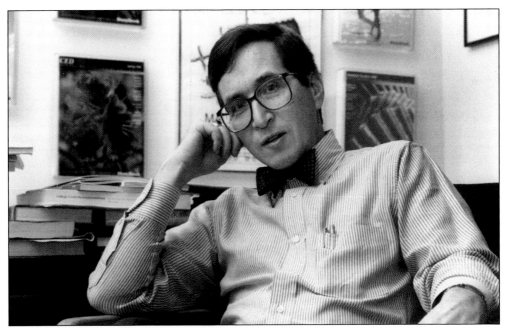

The School of Professional Development was originally founded as the Center for Continuing Education in 1967. In 1987, under the guidance of the school's present dean, Dr. Paul J. Edelson, the center was renamed the School of Continuing Studies, in recognition of its broadened academic mission. In 1995, it became the School of Professional Development and Continuing Studies, in order to more accurately reflect the school's educational programs and goals. The school has nearly 9,000 alumni. (Photograph by Susan Dooley.)

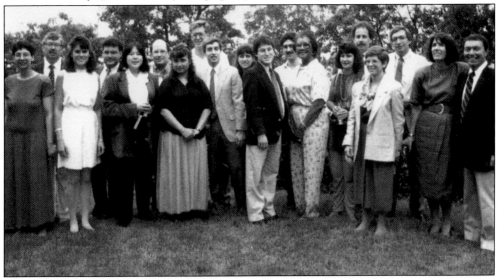

Board members of the Stony Brook Alumni Association attend a reception at the president's home in the spring of 1990. Pictured, from left to right, are Susan Bonfield Herschkowitz, James F.X. Doyle, Jackie Delaney, Steve Bernardini, Grace Lee, Earle Weprin, Karen Persichilli, Sheldon Cohen, Jay Schoenfeld, Jackie Zuckerman, Glenn Greenberg, Richard Zuckerman, Willa Hall Prince, Fern Cohen, Norman Prusslin, Debbora Ahlgren, Frank Maresca, Diane Sullivan Orens, and Joe Buscareno.

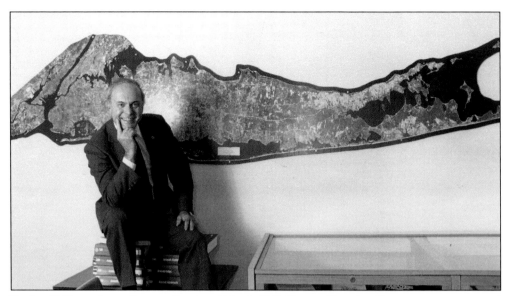

Dr. Lee E. Koppelman, former director of the Suffolk County Planning Department, was named director of Stony Brook's Center for Regional Policy Studies in 1988. The center addresses issues of environment, economic development, and education throughout Long Island and serves as a link between the university and the public sector. Research is conducted into public policy issues, and the center provides government agencies with detailed statistical material used for planning and operating decisions.

Stony Brook graduate and anatomical scientist Dr. Diane Doran was selected in 1990 to head the Karisoke Research Center in Rwanda, Africa, to continue Dian Fossey's work (depicted in the film *Gorillas in the Mist*). Doran, who studied all three species of African apes, lived in primitive conditions for two years in the tropical rain forest in order to carry out her research, which provided a unique perspective on the origin of the human species and evolution.

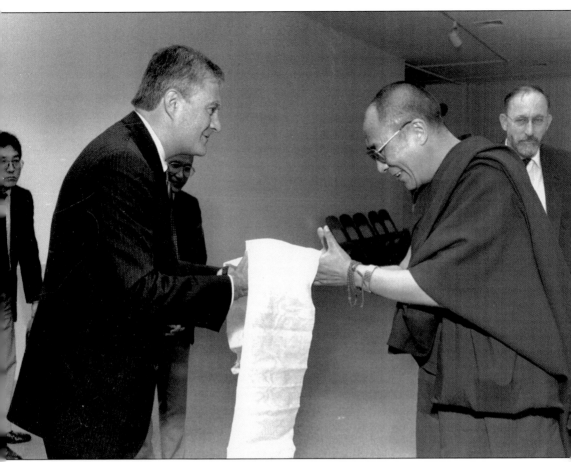

His Holiness the 14th Dalai Lama of Tibet, Tenzin Gyatso (front right), visits Stony Brook University and is greeted by Pres. John Marburger (front left). A Buddhist monk, the Dalai Lama is the head of state and spiritual leader of the Tibetan people. Universally known as a leading human rights and world peace advocate, he received the 1989 Nobel Peace Prize and numerous other awards—the Bi-Annual Award of the Foundation for Freedom and Human Rights, the Raoul Wallenberg Congressional Human Rights Award, the Albert Schweitzer Humanitarian Award, and honorary degrees from universities around the world. The Dalai Lama's lecture, entitled "Tibet: Past and Present," was given at the Staller Center for the Arts as part of the university's Distinguished Lecture Series. During his September 1990 visit to Stony Brook, the Dalai Lama received the honorary degree of doctor of humane letters from Frederick Salerno chair of the State University of New York's Board of Trustees. (Photograph by Maxine Hicks.)

The Campus Services Quality Assurance Group, composed of Stony Brook faculty and staff, was formed at Stony Brook to monitor campus services provided by the university. At the Tabler Quad bus stop in the summer of 1990, the group dedicated a garbage can donated by Dr. Edward O'Connell (left), environmental health and safety physicist and radiation officer. Pictured with O'Connell is John Marchese, assistant director for hospital safety. (Photograph by Maxine Hicks.)

Alonzo Hilton-Shockley Jr. (left) receives from Stony Brook Pres. John Marburger a United Nations Day proclamation signed by Patrick Halpin, Suffolk County executive. Shockley was membership vice president of the Mid-Long Island Chapter of the United Nations Association of the United States of America at the time of the proclamation, in October 1990. (Photograph by Maxine Hicks.)

our neighbor

Stony Brook is the leading ⸻ ⸻d innovative treatment of Lyme disease. In 1983, Dr. Jorge Benach, an assistan⸻ ⸻hool of Medicine, isolated for the first time the organism that causes Lyme d⸻ ⸻'andmark publication in the *New England Journal of Medicine*. He had particip⸻ ⸻ry of the spirochete itself in 1982. Benach is currently director of the Center for In⸻ ⸻eases at Stony Brook.

Dr. Robert R. Sokal, Distinguished Professor of ecology and evolution at Stony Brook, was a pioneer researcher in many areas of the biological sciences. Widely published, he was recognized in 1982 for his work in applying spatial autocorrelation analysis to humans and was credited with being the cofounder of the field of numerical taxonomy.

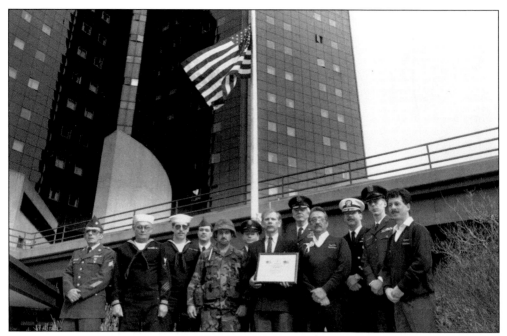

Ceremonies are held outside University Hospital at Stony Brook after the conclusion of the war in the Persian Gulf in 1991. As part of the war effort, a volunteer critical care team of doctors, nurses, and respiratory therapists were sent from Stony Brook Hospital to Europe to treat injured military personnel.

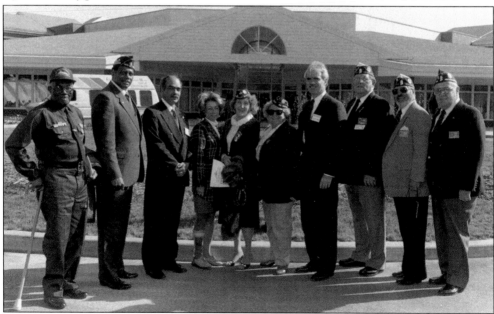

The Long Island State Veterans Home officially opened at Stony Brook in October 1991. The 350-bed skilled nursing care facility provides high-quality, comprehensive health and rehabilitative care to U.S. Armed Forces veterans. An important site for geriatric research, the facility focuses on basic research into the cause of Alzheimer's and other age-related dementia, and provides diagnostic evaluations, counseling, and education.

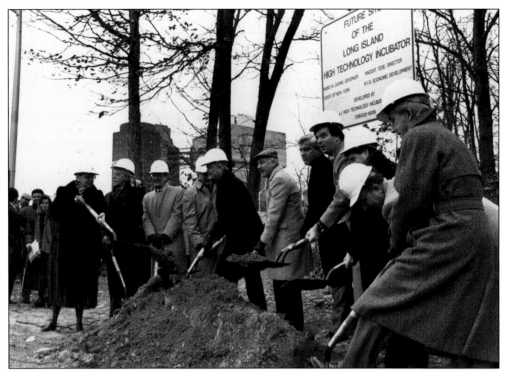

Ground was broken for the Long Island High Technology Incubator in January 1992. Designed to foster cooperation between Stony Brook and local technology companies, the facility is dedicated to the development of high-technology enterprise. The 72,000-square-foot building contains science and engineering labs, specialized research facilities, libraries, and office space. Tenants have access to the university's faculty as potential collaborators, as well as more than 18,000 potential employees and student interns from the university campus. Sen. Kenneth LaValle led the New York State Senate effort to fund the facility, and Gov. George Pataki attended the opening ceremonies in October 1992. (Photograph by Maxine Hicks.)

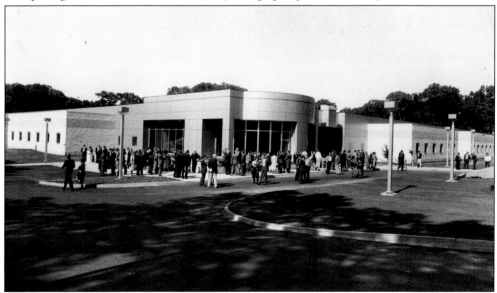

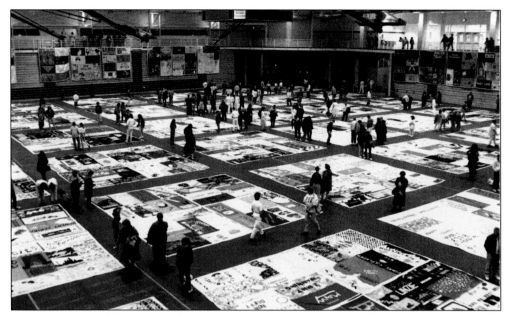

Acquired immunodeficiency syndrome (AIDS), a debilitating and deadly disease, spread rapidly throughout the world during the 1980s. In an effort to use education to control the spread of the epidemic, Stony Brook hosted a display of the AIDS Memorial Quilt in April 1992. The quilt, composed of individual three- by six-foot memorial panels from every state and 28 countries, was exhibited across the country to raise awareness and funds for AIDS service organizations until 1996.

Stony Brook Pres. John Marburger (left) hosts the recipients of the President's Award for Excellence in Teaching at Shorewood, the president's residence, in 1990. With him, from left to right, are the following: (front row) Dr. Joseph W. Lauher, professor of chemistry; and Dr. Paul G. Kumpel, professor of mathematics; (back row) Dr. Judith Tanur, professor of sociology; Dr. Frederick Miller, chair of the Department of Pathology; Dr. Harriet Ray Allentuch, professor of French and Italian; and Dr. Lou Chamon Deutsch, professor of Hispanic languages and literature.

In February 1993, the Staller Center sustained significant flood damage as a result of a water main break. Gov. Mario Cuomo (third from right) is shown surveying the damage with Pres. John Marburger and university officials. The Staller Center reopened in May 1993, after extensive clean up and repair work. A grand piano donated by local songwriter and singer Billy Joel was delivered and installed to help replace the instruments Stony Brook lost in the flood. (Photographs by Maxine Hicks.)

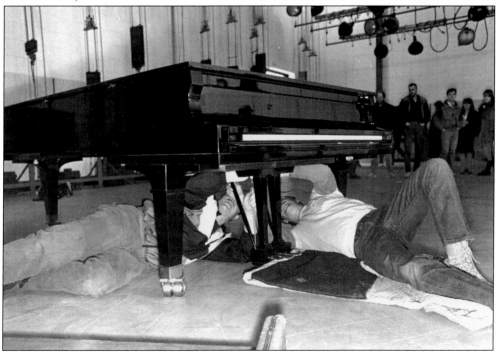

Dr. Shirley Strum Kenny was inaugurated as Stony Brook's fourth president in April 1995. Stony Brook's first woman president, she came to Stony Brook after nine years as the president of City University of New York's Queens College. One of her major goals has been to enhance undergraduate education at research universities. She has also worked to develop Stony Brook's ties with the local community and to strengthen economic development on Long Island through medical and biotechnological advancement.

This picture of three Stony Brook presidents was taken at Shirley Strum Kenny's inauguration as university president in April 1995. Dr. John S. Toll (left), the second to serve as president, took office on April 1, 1965. Dr. John Marburger, third president, served from 1980 to 1995. Each of the presidents has contributed in unique ways to the development and success of the university. (Courtesy of Medical Photography.)

In 1992, the women's volleyball team won the National Collegiate Athletic Association (NCAA) Eastern Regional title, and the men's baseball team captured the Eastern College Athletic Conference (ECAC) Championship. For an exciting new identity in the Division I level, Stony Brook's athletic teams became the Seawolves in 1994. Selected from over 200 possible names, the new nickname became the fourth in the university's history. Pictured with the new mascot is women's basketball coach Beckie Francis (back left) with members of the 1994–1995 team.

Members of Stony Brook's Kickline, now known as the Stony Brook Dance Team, perform at university and athletic events to promote and inspire school spirit. The team performs jazz, pom, and funk/ hip-hop routines at basketball games and school events, and competes on local and national levels. Fund-raising, dance classes, and community service are also part of the team's commitment to Stony Brook.

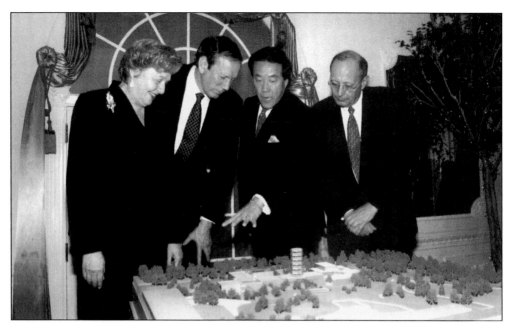

Charles B. Wang (third from left), the founder and chairman of Computer Associates, one of the world's largest independent software developers, pledged $25 million to Stony Brook for the construction of the Charles B. Wang Asian American Studies Center in 1996. Viewing a scale model of the building with Wang are, from left to right, Pres. Shirley Strum Kenny, Gov. George Pataki, and Sen. Alfonse D'Amato. Scheduled for completion in 2002, the center (below) was designed by architect P.H. Tuan to have gardens, a waterfall, ponds, a large food court, a private faculty dining room, an auditorium, and state-of-the-art electronic equipment. Once completed, it was slated to be transferred to the Stony Brook Foundation, becoming its largest private donation to date. (Photograph by Ja Young.)

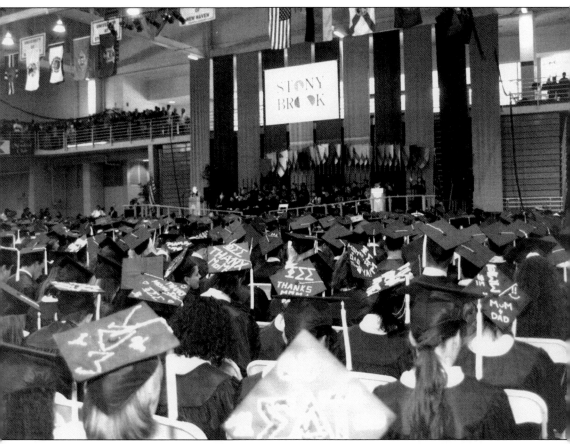

During the 1990s, Stony Brook received many awards and distinctions, particularly in the sciences. In 1991, Stony Brook's National Science Foundation Science and Technology Center in High Pressure Research, Earth, and Space Sciences—the first Science and Technology Center established at a New York State public institution—became the first public institution in New York State to be ranked Research Type 1 by the Carnegie Foundation. The National Science Foundation established two Materials Research Science and Engineering Centers at Stony Brook in 1996, making Stony Brook the only public university in the nation with two such centers. A 1997 national study ranked Stony Brook one of the nation's top three public universities in the combined research areas of science, social science, and arts and humanities. Named as one of 16 leadership research institutions by the Association of American Colleges and Universities, Stony Brook became a member of the Association of American Universities (AAU) in May 2001, joining an elite group of the finest American research universities, including Columbia, Cornell, Harvard, Johns Hopkins, Massachusetts Institute of Technology, Princeton, Stanford, and Yale. Illustrating the value of a Stony Brook education are the 1996 graduation ceremonies.

Pres. Shirley Strum Kenny was instrumental in having a new logo designed to enhance Stony Brook's image as a "rising star." Meant to symbolize Stony Brook's embodiment of a new generation of universities, the logo represents the qualities of ingenuity and inventiveness that defines Stony Brook as a leader in technological innovations for the future. The slogan on the back of the bus proclaims, "You are following some of the brightest minds in the country."

As part of an effort to support and recognize its faculty, Stony Brook hosts an Artists, Authors, and Editors Reception each year and publishes an annual brochure highlighting faculty achievements. The event, coordinated by the Office of Conferences and Special Events, features the work of Stony Brook faculty authors, editors, musicians, translators, artists, composers, and performers. The published works are displayed in the Galleria of the Frank Melville Jr. Memorial Library.

In May 1997, the Carol M. Baldwin Breast Care Center was dedicated at ceremonies attended by, from left to right, Dr. Norman Edelman, vice president Health Sciences Center, and dean, School of Medicine; Carol Baldwin; Pres. Shirley Strum Kenny; Alec Baldwin; and Dr. Michael Maffetone, vice president, healthcare affairs. A full range of health services are available at the center, which serves as a site for clinical and research programs, assuring that the latest therapeutic advances in the treatment of breast cancer are available.

University Pres. Shirley Strum Kenny cut the ribbon to start the Walk for Beauty in a Beautiful Place in 1997. This annual six-kilometer walk through historic Stony Brook Village raises money to support the University Medical Center's boutique for women suffering with cancer. Pictured, from left to right, are Gloria Rocchio, president of the Stony Brook Community Fund; Nora Bredes, county legislator; Steven Englebright, New York State assemblyman; and Joan Hudson from the Suffolk County Department of Women's Services.

Stony Brook's new Student Activity Center, begun in 1993, was dedicated in September 1997. Attending the ceremonies in celebration of the event were, from left to right, Pres. Shirley Strum Kenny; Diane Lopez, vice president, Polity; Roy Roberts, Graduate Student Organization vice president; Dr. Frederick R. Preston, vice president, student activities; and New York State Assemblyman Steven Englebright. The Student Activity Center (below), located in the heart of the Academic Mall, features an acoustically superior 550-seat auditorium, nine meeting rooms, and multipurpose rooms for dances, receptions, award ceremonies, concerts, and conferences. Phase II of the center, scheduled for completion in 2002, includes two multipurpose ballrooms, student club space, and an expanded fitness center.

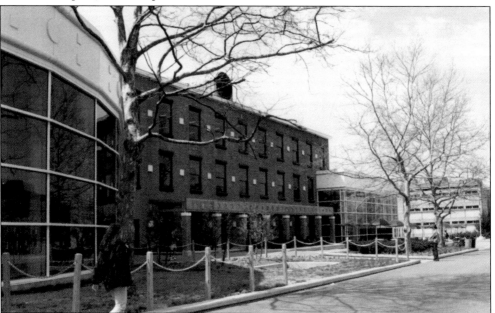

Dr. C.N. Yang (front left) was the first Nobel laureate to join Stony Brook's faculty. In 1992, Yang was awarded the University Medal on the occasion of his 70th birthday. He was recognized in 1998 for his 32 years of service to the university with the first Stony Brook Council Medal. At his retirement celebration in 1998, he shakes hands with Dr. Rollin Richmond, provost. (Photograph by Medical Photography.)

The Center for India Studies opened in April 1997. Supported by the India Society, which was founded in 1989 by Stony Brook faculty and students to sponsor activities contributing to an understanding of India's rich heritage, the new center is designed to promote a better understanding of Indian thought, culture, and civilization. The center was opened as a result of student interest and was funded by contributions from the Indian-American community. (Photograph by Medical Photography.)

Stony Brook celebrated its 40th anniversary in 1998 with a variety of special activities and community events. Faculty, staff, students, and community residents joined Pres. Shirley Strum Kenny on the Academic Mall to blow out the candles on the largest birthday cakes ever seen on campus. A celebration dinner was held in the Student Activity Center, and festivities continued with fireworks by the world-renowned Grucci pyrotechnic firm and an outdoor celebration including free music and other entertainment, cake, and small mementos.

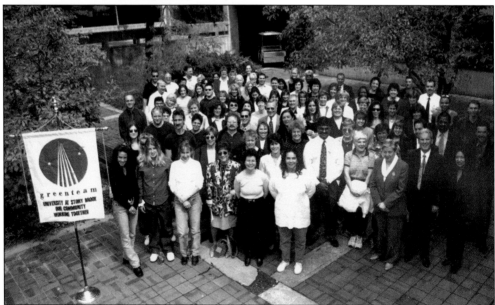

The Green Team concept was first discussed in January 1996. Pres. Shirley Strum Kenny fully supported the joint effort of students, faculty, and staff working together to beautify Stony Brook and create a sense of ownership and increased pride in the physical appearance of the campus. The staff of the *Statesman* became the first student group to participate in the effort. The first year, 18 gardens were created. Currently, there are 94 Green Teams, with more established each year.

Six

COMMUNITY, COMMITMENT, AND CHARACTER

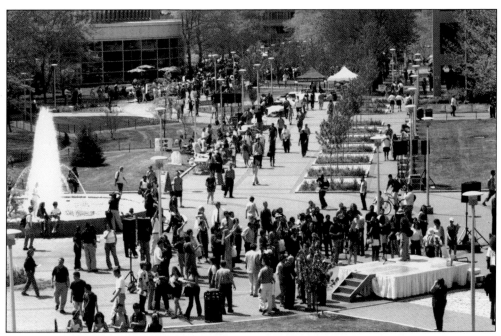

To fulfill Pres. Shirley Strum Kenny's vision of a "heart of the campus," the six-acre Academic Mall was landscaped in 2000 with fountains, trees, plants, benches, tables and chairs, and a "brook." The new fountain serves as the backdrop for campus events. The inaugural Fountain Festival was held in 2000 in celebration of the completion of the fountain and landscaping project. More than 3,000 students, faculty, and staff attended the day's activities.

Renowned for its talented artists and musicians, Stony Brook University works to make its programs, productions, and performing groups accessible to the local community. The library exhibit area in the Melville Library features free displays of work by graduate art students; the Stony Brook Union Gallery features displays of painting, sculpture, prints, photography and fine crafts; the university Art Gallery offers shows by contemporary artists. Stony Brook's many performing groups include the Camerata Singers and Stony Brook Chorale, the Contemporary Chamber Players, the University Wind Ensemble, the Stony Brook Jazz Ensemble, the Stony Brook Opera, the University Orchestra, and the Stony Brook Symphony Orchestra.

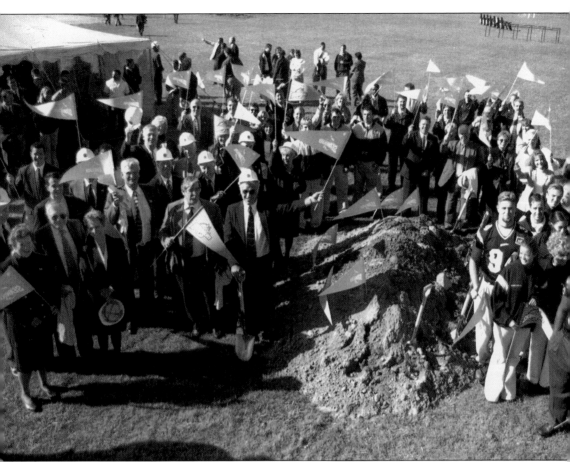

Beginning in 1999, the men's and women's sports teams at Stony Brook University became eligible to compete in Division I National Collegiate Athletic Association (NCAA) play. In October of that year, ground was broken for a new 7,500-seat athletic stadium designed to properly host Division I sport events at Stony Brook. The stadium is expandable to hold 15,000 spectators. The $22 million, four-level facility will host Stony Brook's football, soccer, and lacrosse teams, and will provide a facility for high school championship games, as well as community amateur and professional sports competitions. Situated 14 feet below grade, the weatherproof, standardized playing field has shock-absorbing artificial turf composed of sand and granular rubber material. With official opening ceremonies planned for September 2002, the new stadium has the potential to attract talented student athletes interested in playing at the university, and will enhance the Stony Brook campus.

Dr. Yacov Shamash, dean of the College of Engineering and Applied Sciences and the Harriman School for Management and Policy, was appointed in 1999 to the position of vice president for economic development. Shamash is responsible for developing the economic relationship between the university, the private sector, and the government. The Office of Economic Development works to link the academic and research resources of the Stony Brook campus community with the economic needs of the region and state.

Stony Brook's Centers for Molecular Medicine and Biology Learning Laboratories opened in 1999. The new building was dedicated in November at ceremonies attended by, from left to right, Dr. Norman Edelman, vice president of the Health Sciences Department and dean, School of Medicine; Steven Englebright, state assemblyman; Mary O. Donohue, lieutenant governor of New York State; Pres. Shirley Strum Kenny; Dr. Gail Habicht, vice president, research; Ann Forkin, special events director; Richard Nasti, chair, Stony Brook Council.

In the fall of 2001, Stony Brook University was invited to join the America East Athletic Conference (AEAC). This meant that the Seawolves became eligible for the conference's automatic bid to participate in National Collegiate Athletic Association (NCAA) Tournaments. Established in 1979 as the Eastern College Athletic Conference (ECAC) North, the comprehensive America East is one of the nation's leading Division I conferences providing access for postseason play. A press conference was held at the university to announce the invitation. Sen. Kenneth LaValle is pictured (above) addressing members of the media as Pres. Shirley Strum Kenny announced Stony Brook's acceptance into America East. Pictured in action are members of Stony Brook's 1996 football team (below).

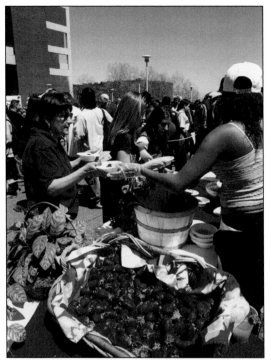

Held on the Academic Mall in the spring, Stony Brook's annual Strawberry Fest gives the university's students, faculty, and staff an opportunity to sample a wide variety of strawberry treats while enjoying a fun-filled day on campus. The event's offerings include everything—plain strawberries, fresh strawberry shortcake, chocolate covered strawberries, strawberry daiquiris, strawberry crepes, and cool strawberry frappes.

Homecoming 2001 was celebrated in style at Stony Brook, with the selection of a king and queen, the Homecoming Parade, a pep rally, half-time festivities, contests, kickoffs, and a carnival-festival. Annual weekend activities include entertainment, games, guest appearances, and prizes. The Seawolves elevation to Division I generated new levels of excitement. Attendance was high, with nearly 4,000 fans in the stands for the Homecoming game and more than 1,300 alumni and friends participating in the Alumni Reunion Tent festivities.

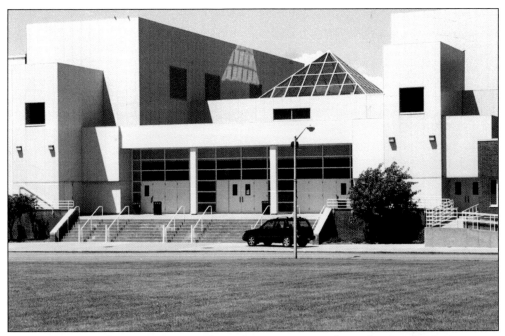

Stony Brook's Indoor Sports Complex (above), connected to the Pritchard Gym, was completed and dedicated in October 1990. The Sports Complex contains a main arena with a seating capacity up to 5,000, and is open to the public when not being used by the university. The facilities available include an indoor running track, a weight room, racquetball and squash courts, a 25-yard pool, a dance studio, an exercise room, and multipurpose courts for basketball, volleyball, badminton, and indoor soccer. To celebrate the opening of basketball season, cheerleaders (below) perform during the annual Midnight Madness event held at the Sports Complex Arena.

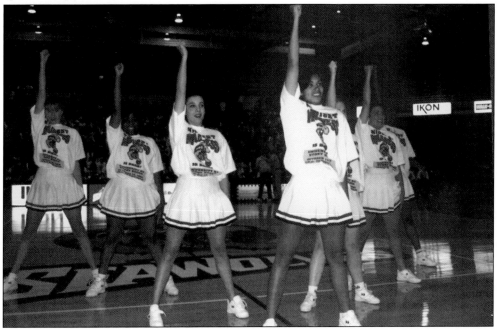

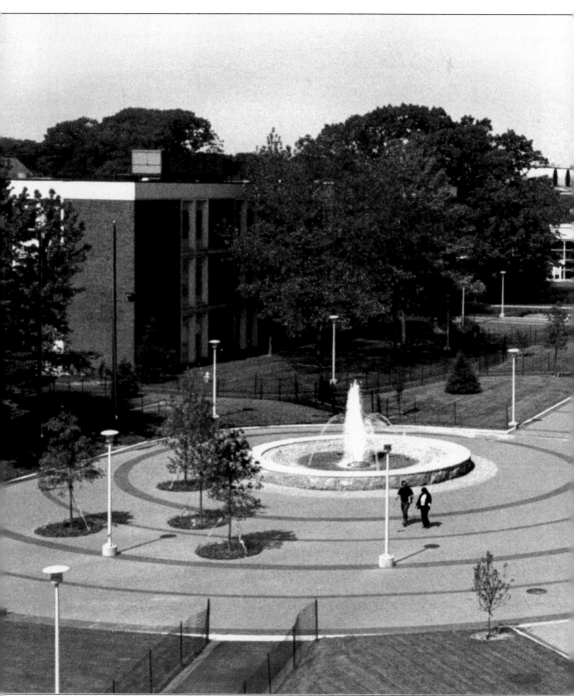

The Academic Mall illustrates Stony Brook's recent physical transformation. Research and economic achievements have been significant as well. In 1998, Stony Brook placed 12th among all U.S. colleges and universities in patent royalties generated from inventions licensed to industry ($12 million) and accounted for 98 percent of all SUNY-system licensing revenue. Between 1994 and 1999, the university recorded 319 invention disclosures, 142 patents issued, and 161 licenses. Stony Brook's economic development program created a business volume

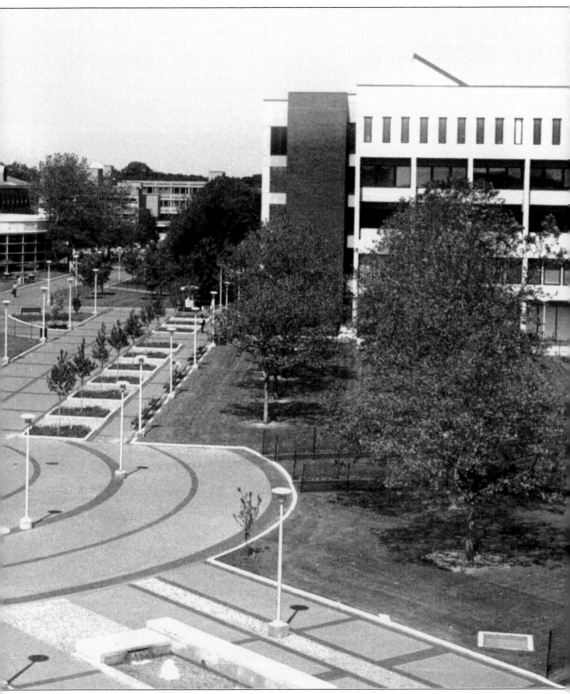

of $180 million, involved more than 250 firms, and accounted for 3,200 jobs by 1998. Stony Brook is Long Island's largest single-site employer and currently provides over 12,000 full- and part-time jobs. Enrollment in the university as of 2000 was more than 18,600 students in both undergraduate and graduate degree programs, with a faculty of 1,682. The campus now encompasses 123 buildings on nearly 1,200 acres, located between the urban vitality of New York City to the west and the ocean vistas of Montauk Point to the east.

Ride for Life founder Christopher Pendergast (seated, center) arrived at Stony Brook for a rally on May 7, 2001, in the course of his 10-day-long, 175-mile trek across Long Island, from Montauk to Manhattan. Begun in 1998, the Ride for Life was designed to increase awareness of amyotrophic lateral sclerosis (ALS), raise funds for research toward finding a cure, and provide inspiration for those fighting the disease, commonly referred to as Lou Gehrig's disease.

Stony Brook students, faculty, and staff participated in the construction of an affordable new home for a deserving family through the efforts of Habitat for Humanity of Suffolk County in March 2001. The Stony Brook campus community raised $40,000 toward the cost of building the home through departmental and student-run fund-raising efforts. The balance of the money is funded through Habitat for Humanity, and the homeowner family invests 250 hours of labor as a down payment.

Stony Brook's computing environment provides a constantly changing array of hardware, software, network connectivity, and consulting services. The Stony Brook Instructional Networked Computing (SINC) sites, located campus-wide, have a variety of computers software, and printers available for student use, and have consultants available if assistance is required. Meeting the goal of the 1995–2000 Five Year Plan, 100 percent of campus residence hall rooms had computer network access as of 2002.

The University Police Department, formerly known as the Department of Public Safety, maintains jurisdiction over Stony Brook's nearly 1,100-acre campus and 109 buildings. Residence halls are also part of campus patrol duties. Staffed by 100 employees, the department employs 60 sworn peace officers. University police force members serve an important role in educating the campus community on personal safety, risk awareness, crime prevention, drug and alcohol risk awareness, and other safety issues.

Moving ceremonies in October 2001 marked the dedication of the Peace Garden at Stony Brook. The garden, located in the Tabler Quad residential village, features a Peace Pole, donated by the Douglass College Living Learning Center and LI Regional Service-Learning Network. Dedicated to the memory of those lost in the September 11th terrorist attack, members of the Green Team/ Pride Patrol and student volunteers installed the Pole. "May Peace Prevail on Earth" was written on the eight-foot pole in four languages to signify international cooperation.

The Ambulatory Surgery Center at Stony Brook, located next to University Hospital, opened in March 2002 with a preoperative testing area, six operating rooms and two minor procedure rooms, each with the latest equipment and monitoring systems. The state-of-the-art 32,000-square-foot facility was designed for easy accessibility and comfortable outpatient surgery for both pediatric and adult patients.

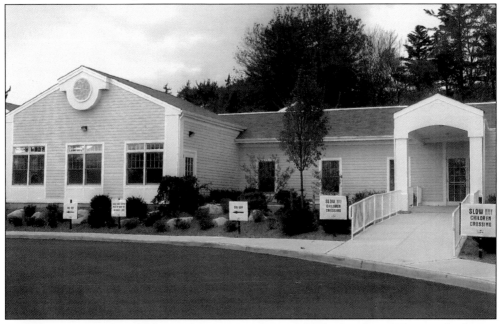

In 1992, Stony Brook's Child Care Services program, established in the 1970s, was the first in Suffolk County to be accredited by the National Academy of Early Childhood Programs and is currently one of the top-rated programs of its kind in the United States. A new building was opened in September 2001 to house the program and allow for expansion and the addition of resources for physically challenged children.

Stony Brook opened a new facility in Manhattan in January 2002. Located on the second floor at 401 Park Avenue South (on the southeast corner of Park Avenue South and 28th Street), Stony Brook Manhattan provides 11 classrooms, offices, 2 conference rooms, and additional multipurpose space for public lectures, alumni gatherings, recruitment efforts, luncheons, and conferences. Stony Brook Manhattan will enhance the educational experiences and opportunities for students, faculty, and alumni living in New York City, as well as attract to the university urban residents who might not have considered Stony Brook. A total of 27 percent of Stony Brook's students come from the five boroughs of New York, and approximately 15,000 alumni live and/or work in the city. Stony Brook Manhattan will allow students and faculty to access resources available in Manhattan—such as museums, historical sites, and the United Nations—and provide New York City facilities for the Stony Brook community. According to Pres. Shirley Strum Kenny, "Stony Brook Manhattan offers the great interdisciplinary strengths of our institution and the creativity and depth of our faculty."